GE AND THANK THE FOLLOWIN

NTED PERMISSION FOR THE F

EFFORTS HAVE BEEN MADE

WE APOLOGISE TO ANY THAT WE HAVE

NER (THAMES ROAD BRIDGE); DYFFRYN

N SEASIDE ESTATE); E T W DENNIS AND

HOPPING CENTRE, TOWNGATE, LEYLAND;

SONS LTD (CAISTER CHALET, CAISTER

CAMP, HAYLING ISLAND, HAMPSHIRE);

CENTRAL LIBRARY, ST NICHOLAS WAY,

OF CHATHAM PRINTERS LTD, LEICESTER,

SALE); JOAN MACRAE (A40 TRAFFIC);

RREG GOCH CARAVAN PARK, MORFA

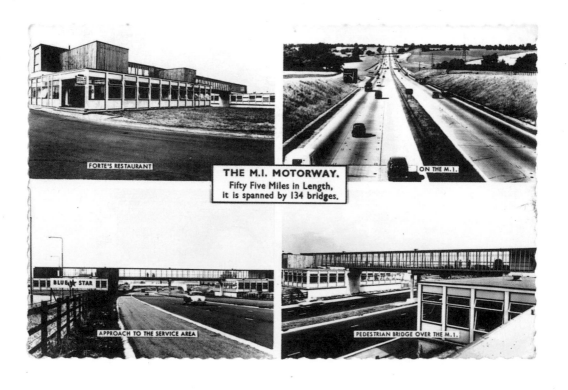

FORTE'S RESTAURANT

ON THE M.1.

THE M.I. MOTORWAY.
Fifty Five Miles in Length,
it is spanned by 134 bridges.

BLUE STAR

APPROACH TO THE SERVICE AREA

PEDESTRIAN BRIDGE OVER THE M.1.

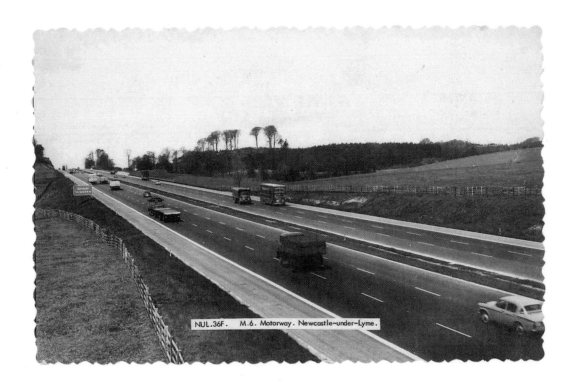

NUL.36F. M.6. Motorway. Newcastle-under-Lyme.

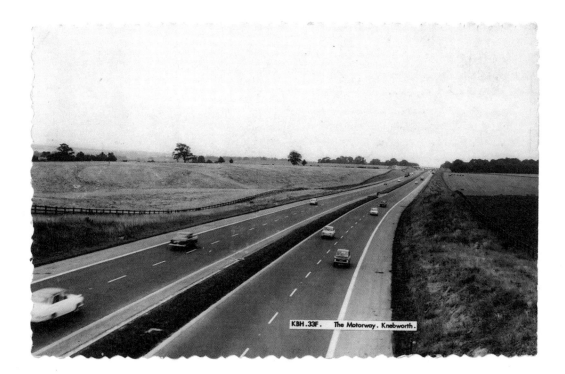

KBH.33F. The Motorway. Knebworth.

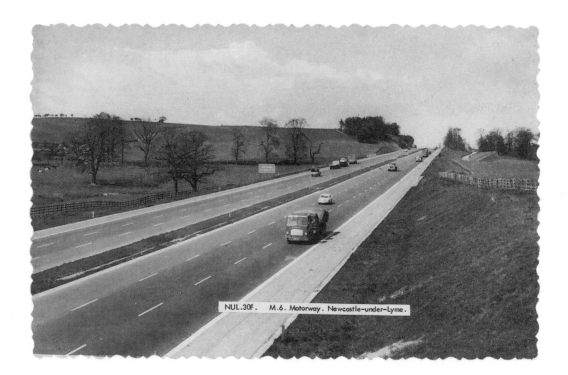

NUL.30F. M.6. Motorway. Newcastle-under-Lyme.

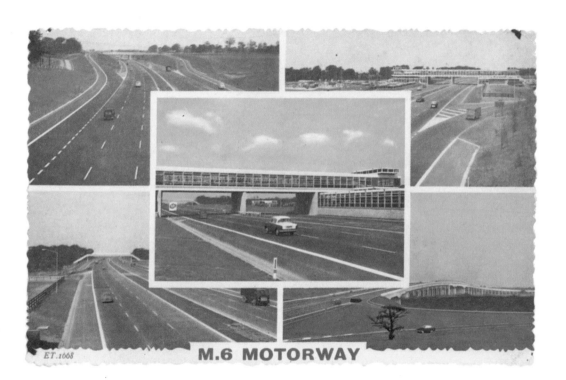

ET.1668

M.6 MOTORWAY

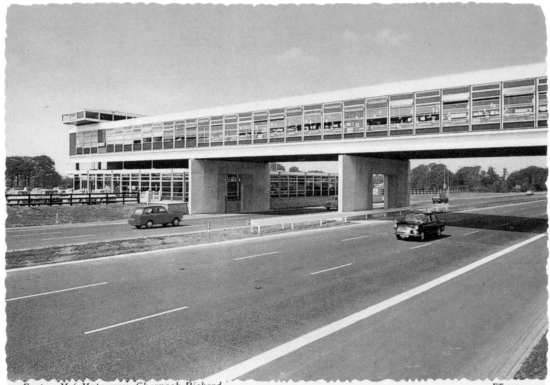

Fortes, M.6 Motorway, Charnock Richard. ET.405

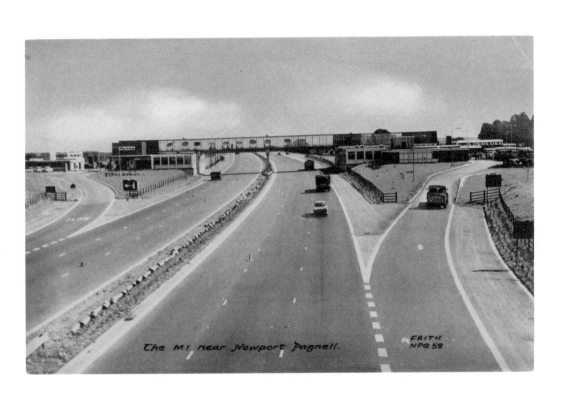

The M1 near Newport Pagnell.

FRITH
NPG 58

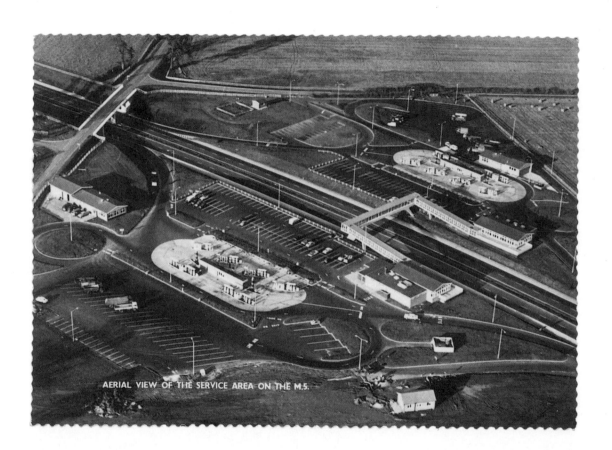

AERIAL VIEW OF THE SERVICE AREA ON THE M.5.

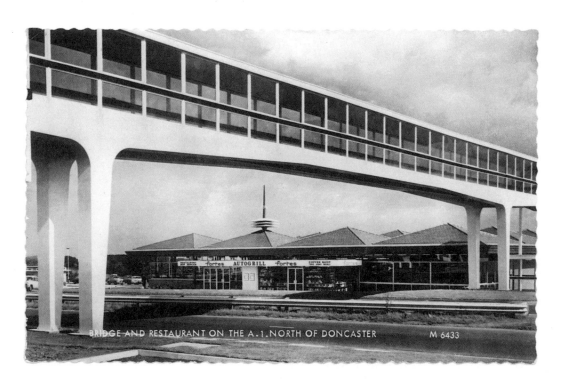

BRIDGE AND RESTAURANT ON THE A.1. NORTH OF DONCASTER M 6433

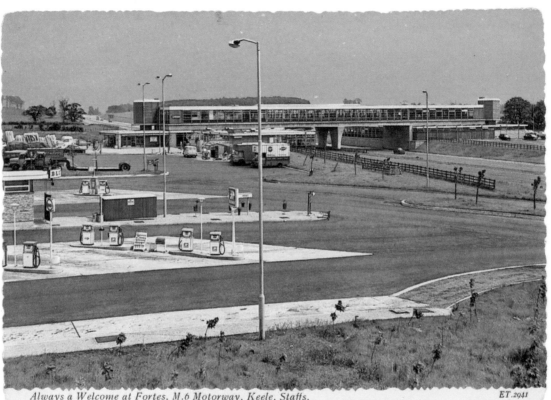

Always a Welcome at Fortes, M.6 Motorway, Keele, Staffs. ET.2941

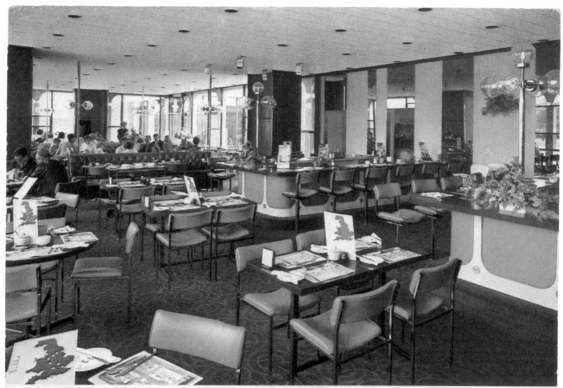

LONDON · The Grill Room, Fortes Scratchwood Service Area, M1 Motorway ET5724

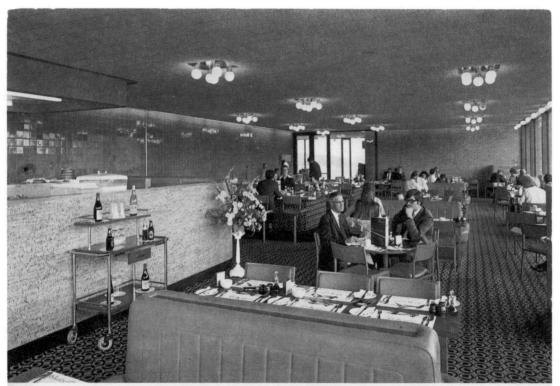

Fortes Corley Service Area. M6 Motorway (Midlands Link) OF 28

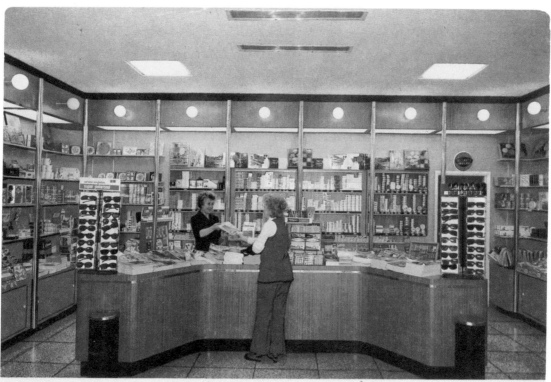

Fortes Corley Service Area. M6 Motorway (Midlands Link)

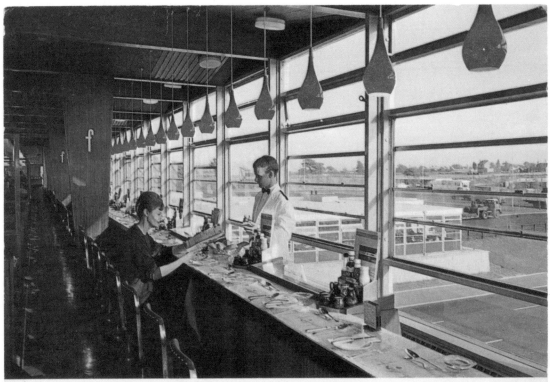

Fortes, M.6 Motorway, Charnock Richard.

ET.3740

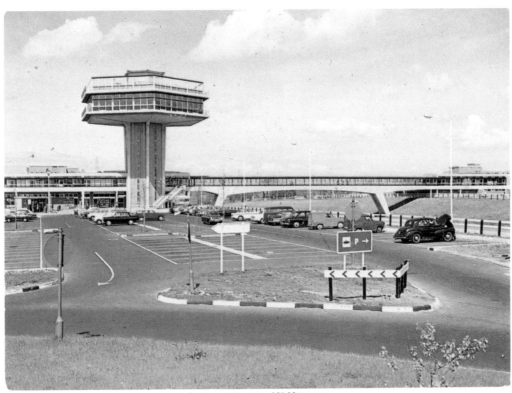

Forton service area, M6 Motorway

CWB.82. THE BYPASS, COWBRIDGE.

MERSEY TUNNEL JUNCTION CHAMBER, SHOWING MAIN AND BRANCH TUNNEL G-1131

INTERIOR OF MERSEY TUNNEL, LIVERPOOL G. 270

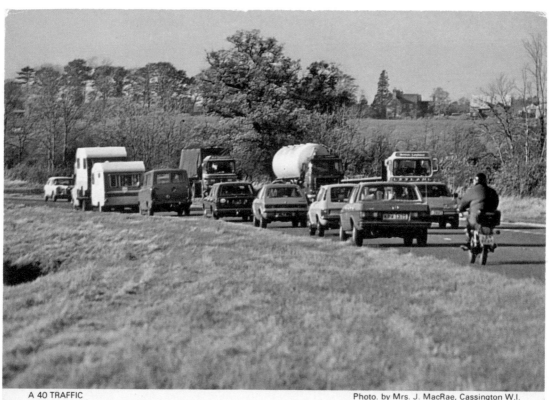

A 40 TRAFFIC Photo. by Mrs. J. MacRae, Cassington W.I.

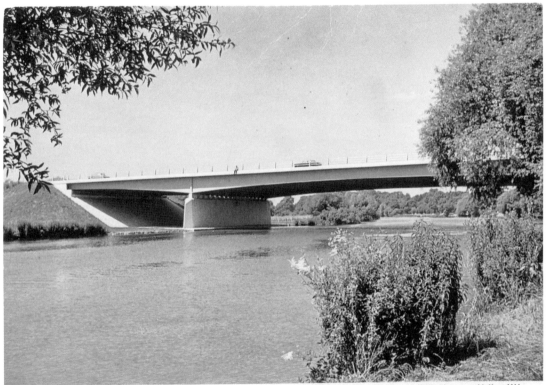

THAMES ROAD BRIDGE

PTH.41. Amlwch Road. Pentraeth.

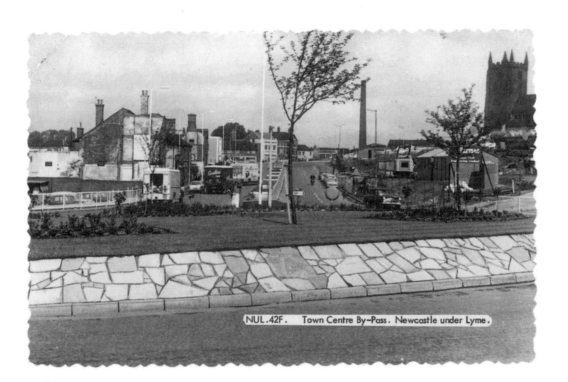

NUL.42F. Town Centre By-Pass. Newcastle under Lyme.

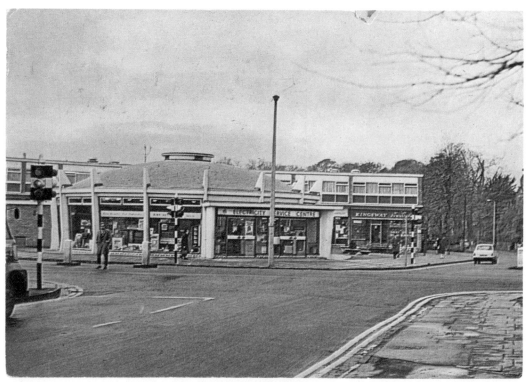

The Cross, Kingswinford, Staffs.

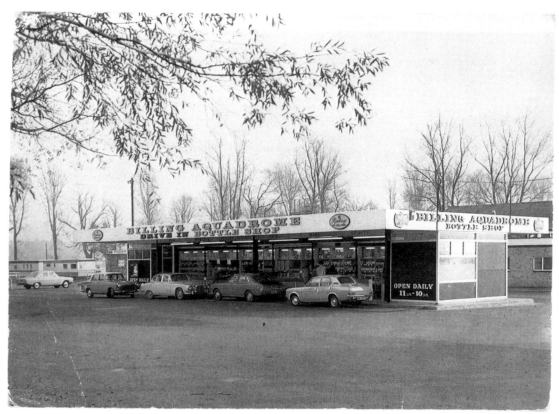

The Drive In Bottle Shop, Northampton

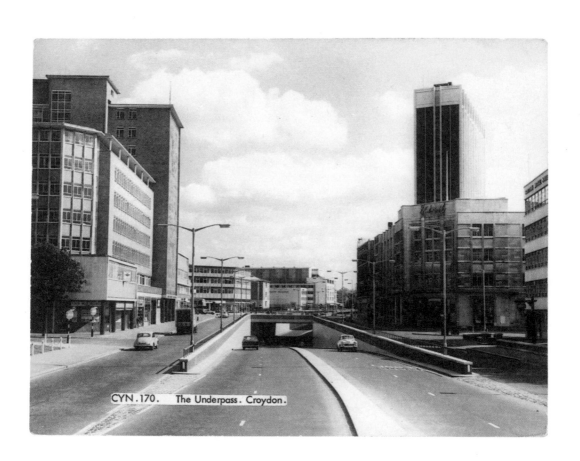

CYN.170. The Underpass. Croydon.

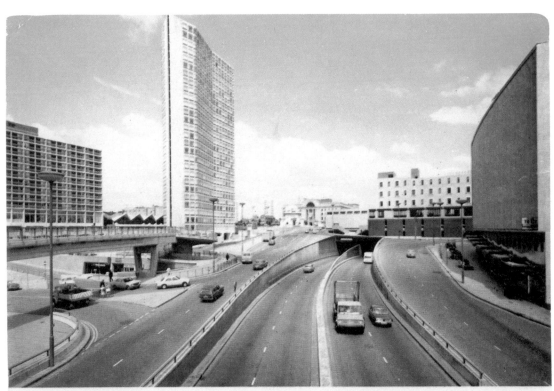

QUEENSWAY, BIRMINGHAM

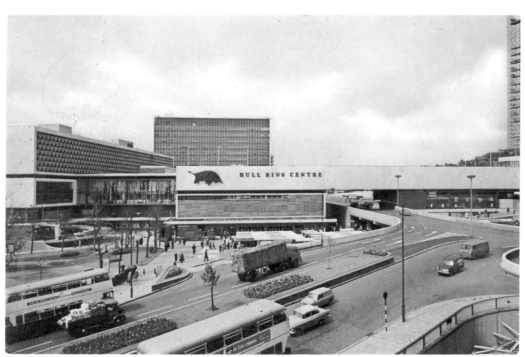

The Bull Ring, Birmingham

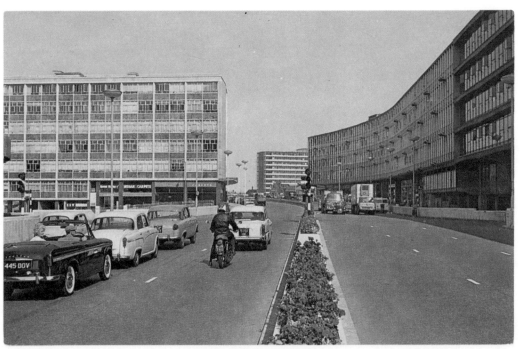

Smallbrook Ringway, Birmingham

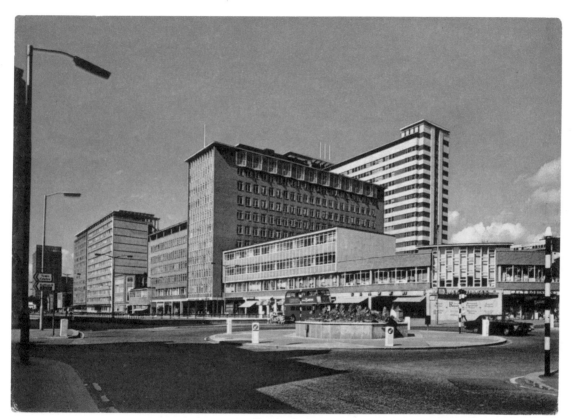

Croydon Centre

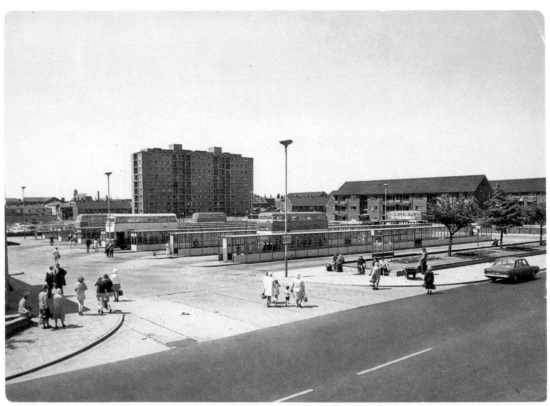

The Bus Station, Ashton-Under-Lyne

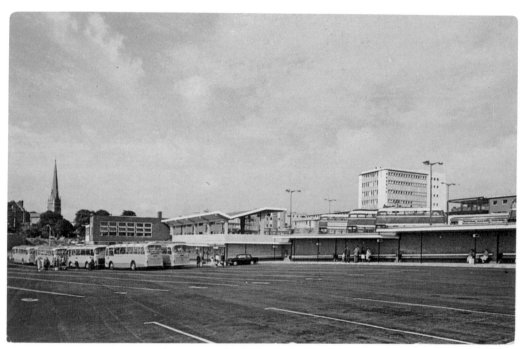

Bus Station, Exeter

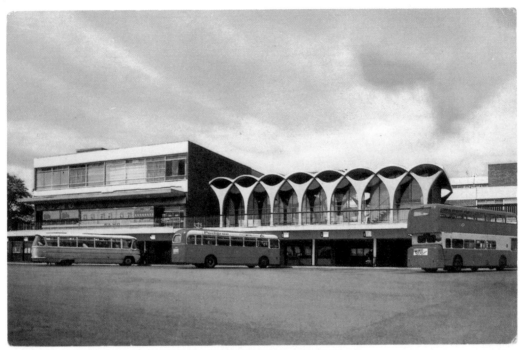

Bus Station and Shopping Centre, Hanley

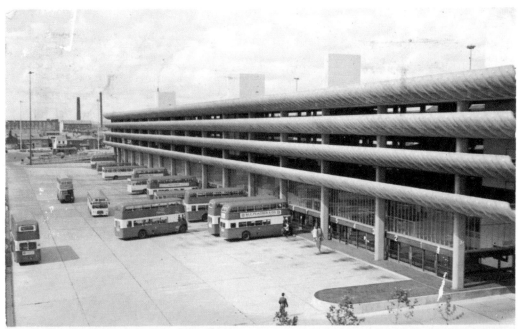

The New Bus Station, Preston (Largest in Britain).

P.2423

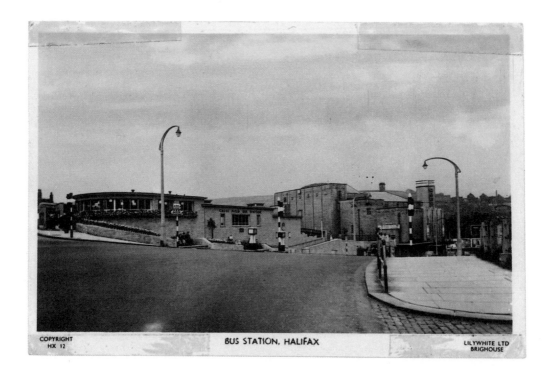

BUS STATION, HALIFAX

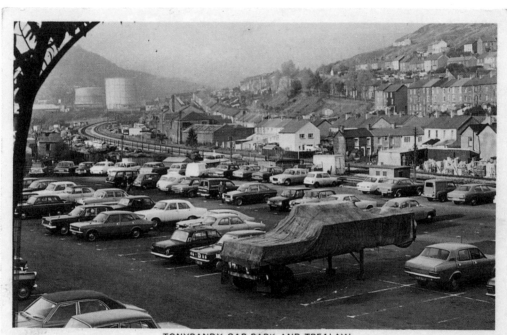

TONYPANDY CAR PARK AND TREALAW

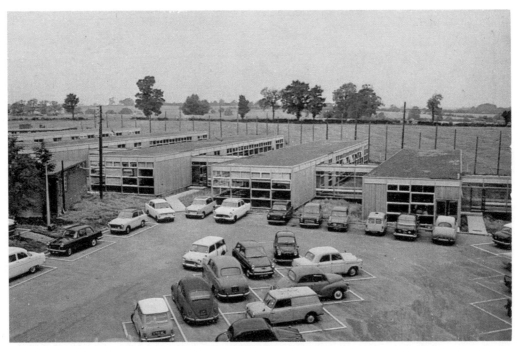

Drayton Parslow Centre

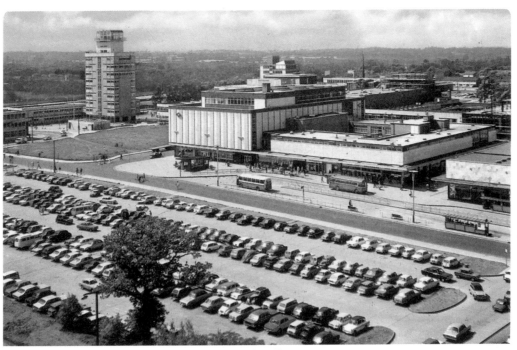

Harlow New Town

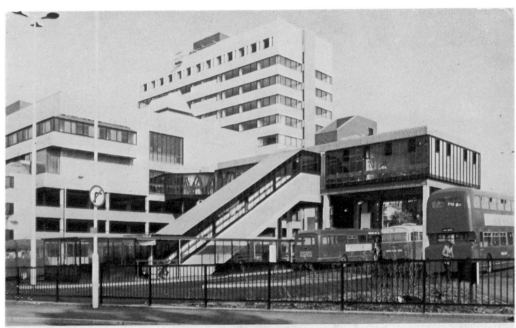

TOWN CENTRE REDDITCH. TRAFFIC INTERCHANGE

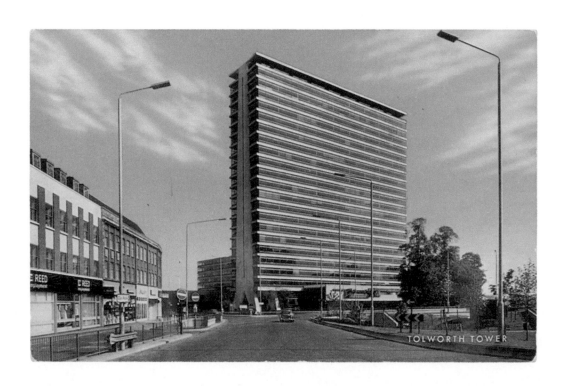

TOLWORTH TOWER

EFY.4 PROSPECT RING, EAST FINCHLEY COPYRIGHT
FRITH LTD

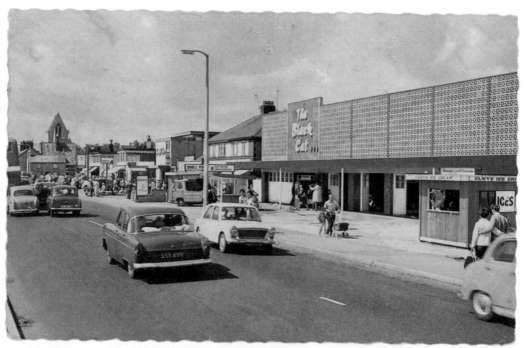

Towyn, Foryd Road

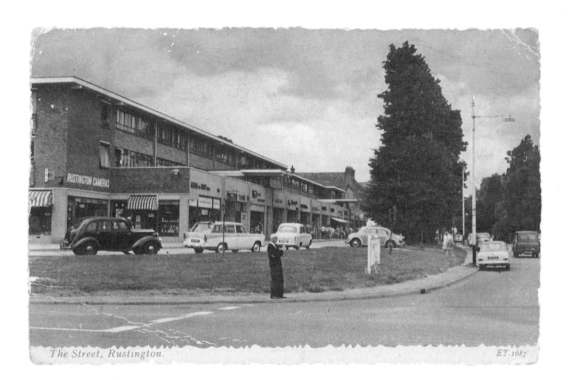

The Street, Rustington.

ET.1687

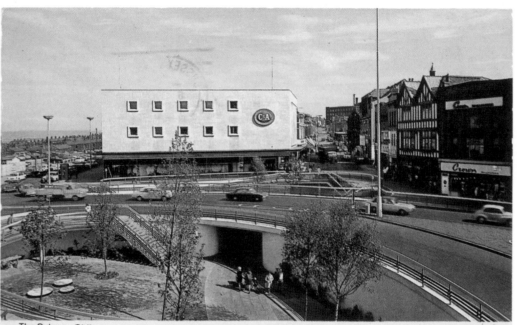

The Subway, Oldham.

3

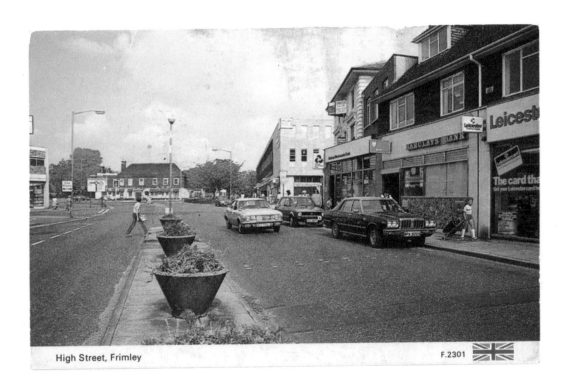

High Street, Frimley

F.2301

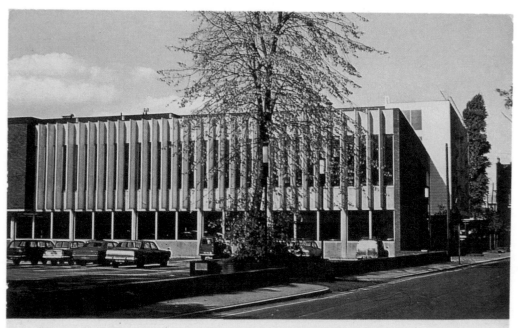

The Leisure Centre, Sale

– KNBT 4477

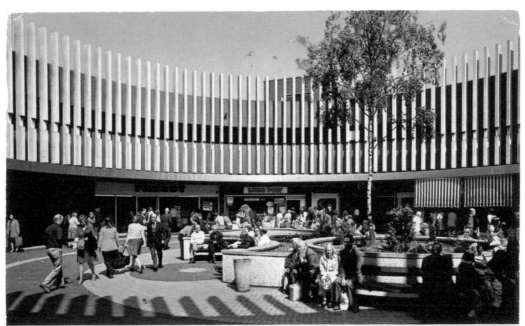

Wulfrun Centre, Wolverhampton

W.0504

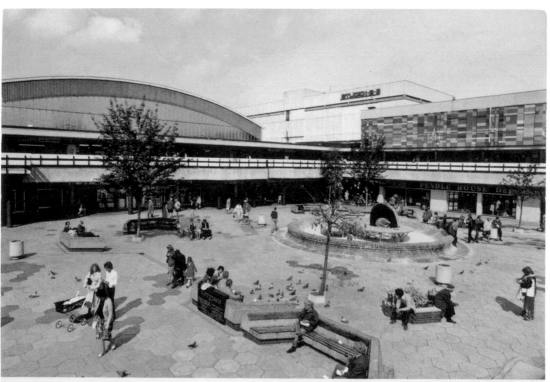

Market Square, Burnley

B.8802L

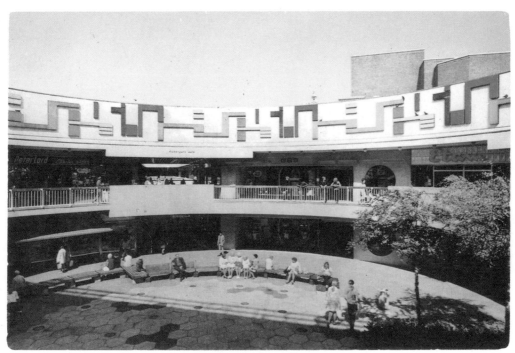

New Shopping Centre, Preston

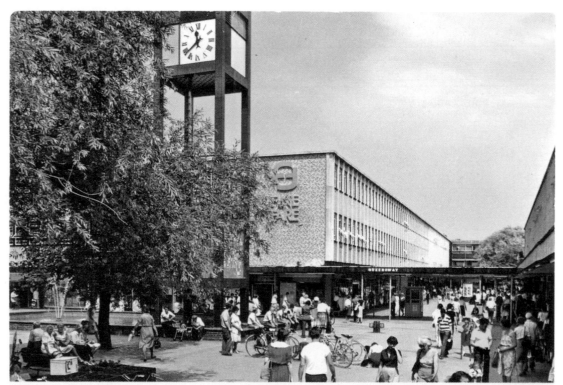

Town Centre, Stevenage

S.7103L

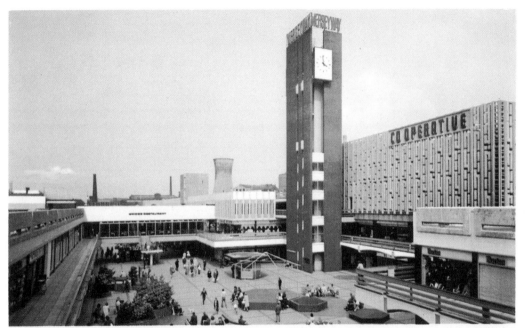

Mersey Shopping Precinct, Stockport

C.2908

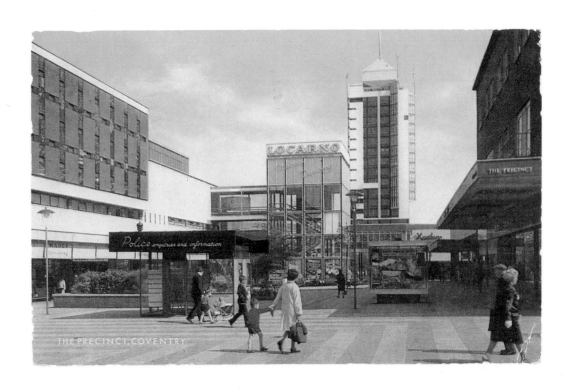

THE PRECINCT, COVENTRY

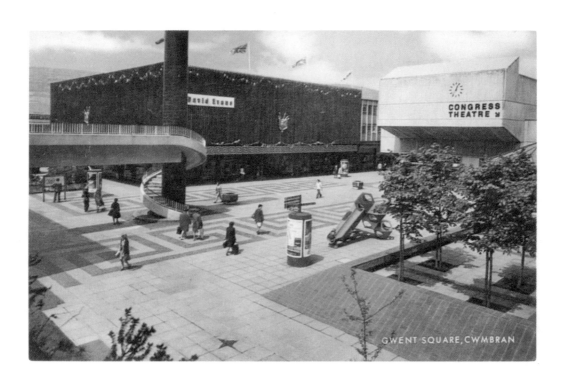

GWENT SQUARE, CWMBRAN

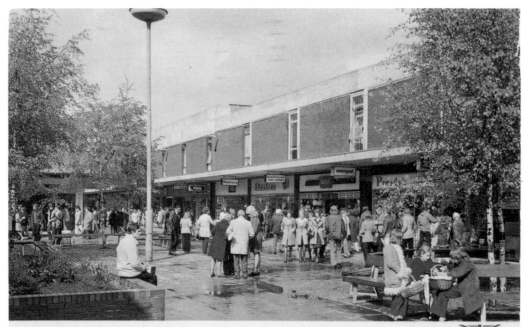

New Shopping Centre, Burton on Trent

B.6805

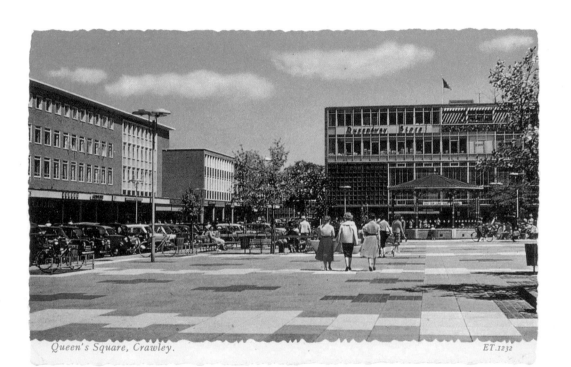

Queen's Square, Crawley.

ET.1232

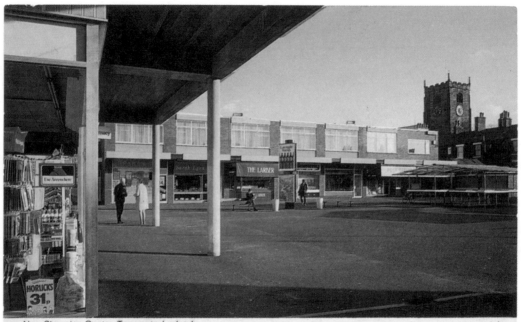

New Shopping Centre, Towngate, Leyland. 1

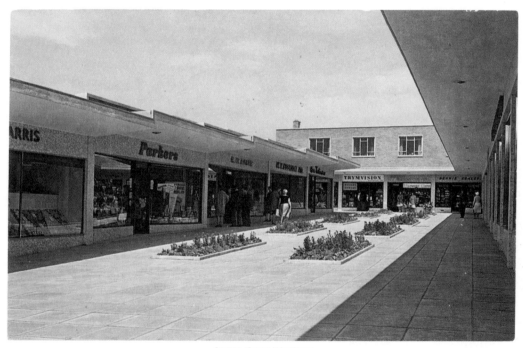

Carlton Court, Westbury

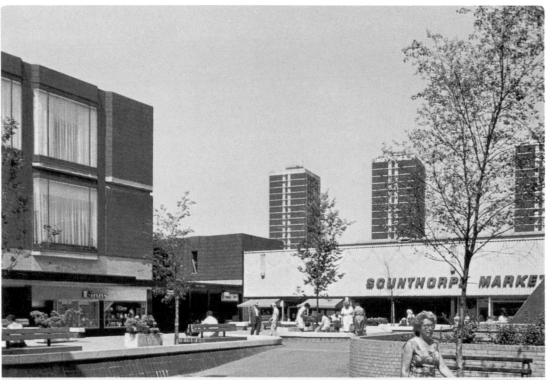

Market Precinct, Scunthorpe

S.0803L

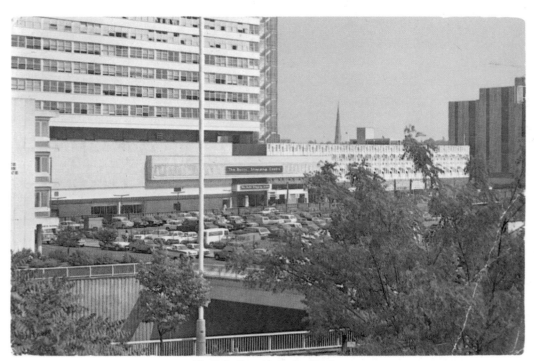

The Butts Shopping Centre, Reading

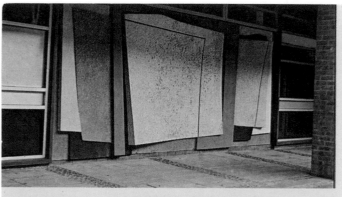

FARNHAM

POST OFFICE

Mural by Michael Fairclough incorporating in abstract form landscape features surrounding Farnham: Alice Holt, Crooksbury Hill, Characteristic shapes and textures of the fields to the West of the town. The town itself is represented by two barlike shapes of red brick.

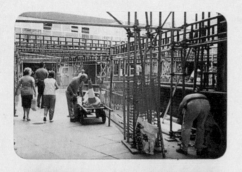
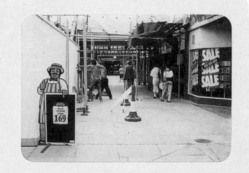
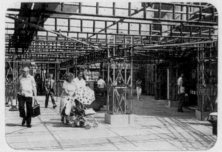

Basingstoke

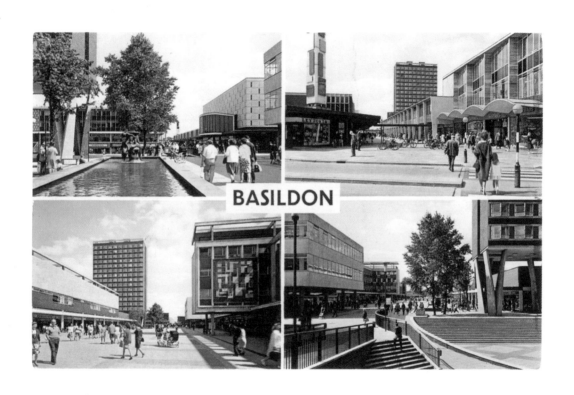

BASILDON

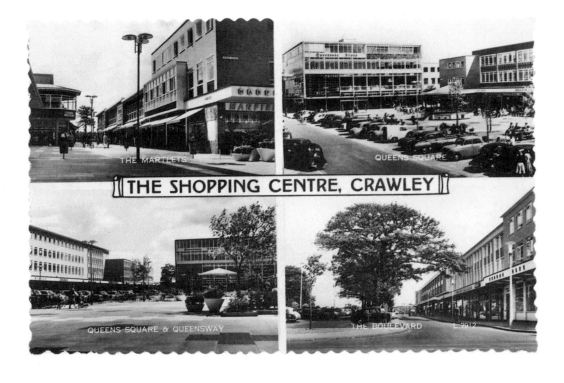

THE MARTLETS

QUEENS SQUARE

THE SHOPPING CENTRE, CRAWLEY

QUEENS SQUARE & QUEENSWAY

THE BOULEVARD

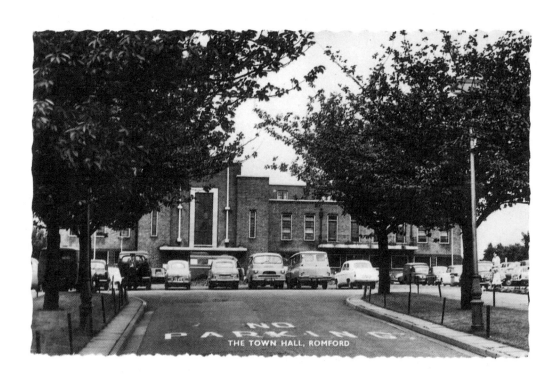

THE TOWN HALL, ROMFORD

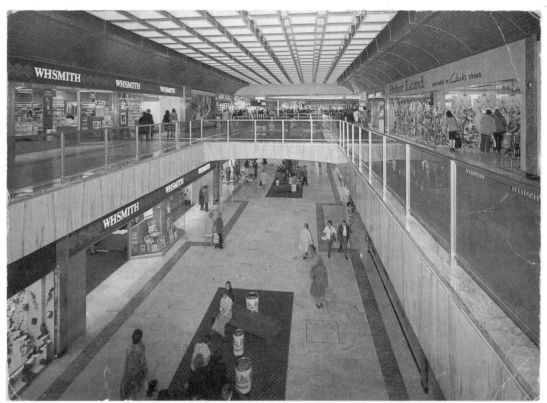

Brent Cross Shopping Centre, London

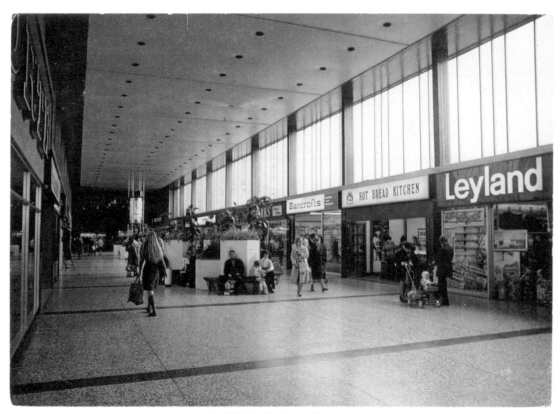

The Mall, Arndale Centre, Crossgates

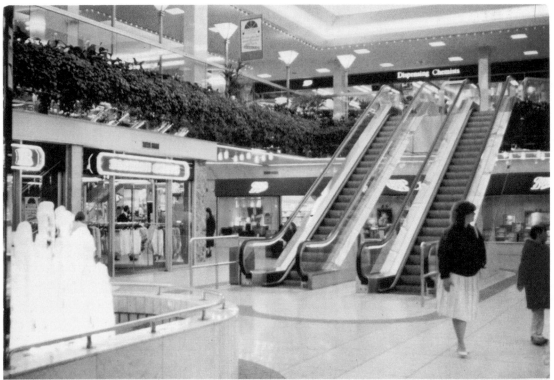

The Frenchgate Centre, Doncaster

D.1715L

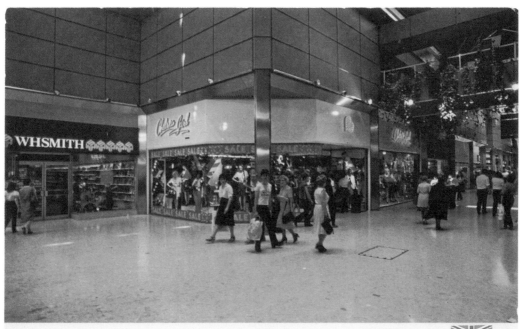

Quadrant Arcade, Swansea

S.2550

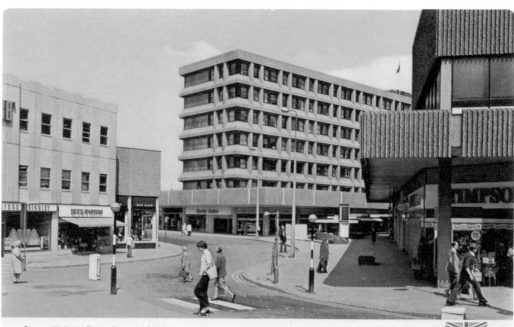

County Hall and Town Centre, Barnsley

B.0402

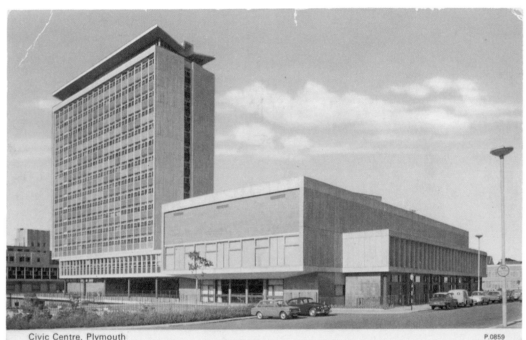

Civic Centre, Plymouth

P.0859

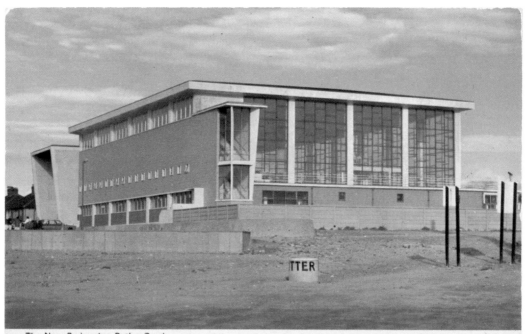

The New Swimming Baths, Crosby

W.4308

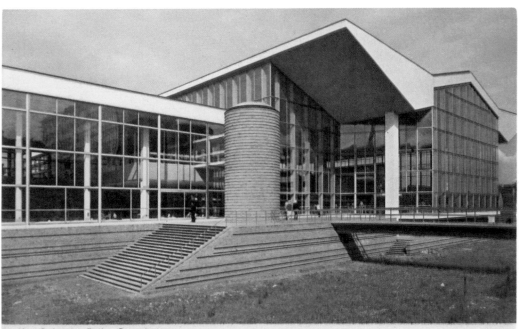

New Swimming Baths, Coventry

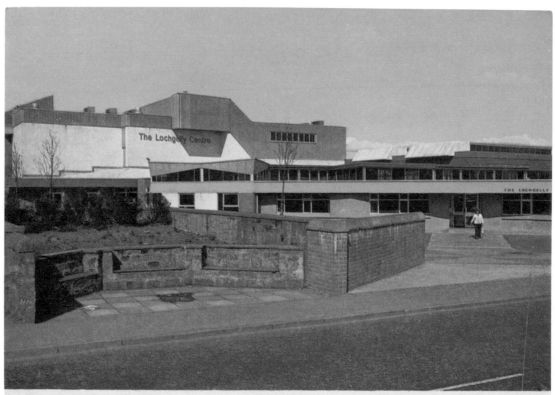

The Lochgelly Centre Complex

5839

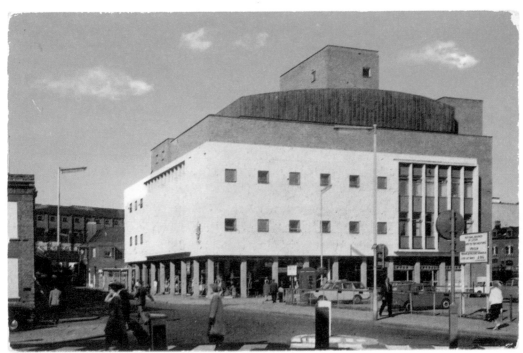

The Library, Luton

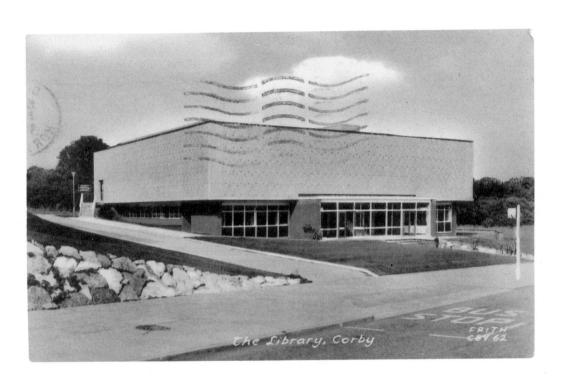

The Library, Corby

FRITH
CBY 62

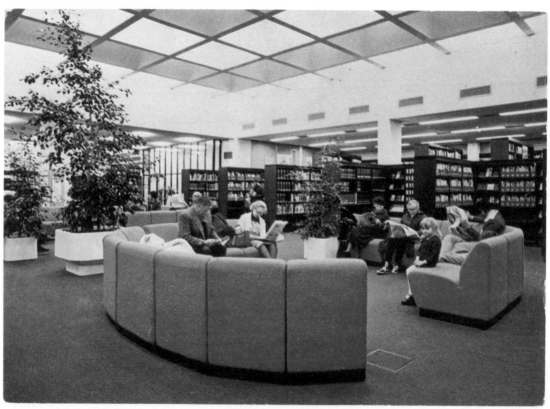

Central Library, St. Nicholas Way, Sutton

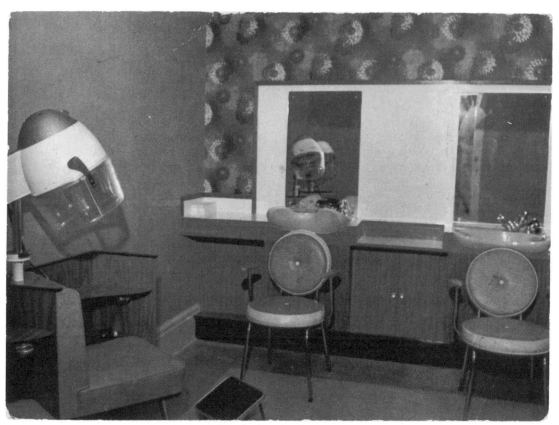

London Transport Benevolent Fund Home at Hythe, near Folkstone

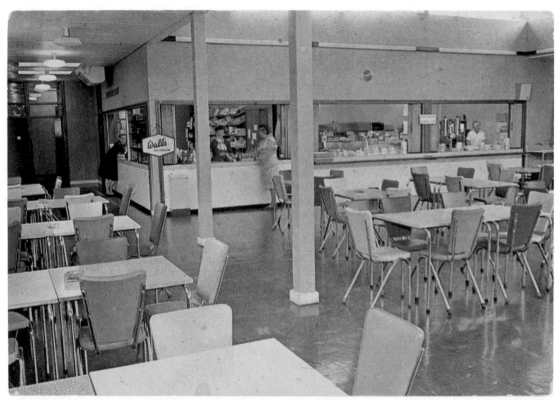

Canteen, Stoke Mandeville Hospital

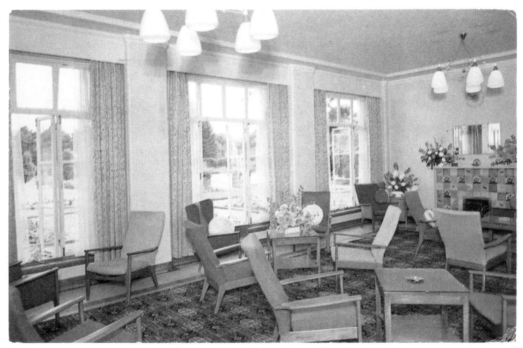

Hearts of Oak Benefit Society, Convalescent Home, Broadstairs

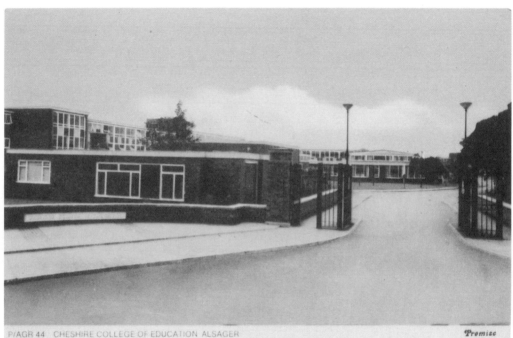

P/AGR 44 CHESHIRE COLLEGE OF EDUCATION ALSAGER *Premisc*

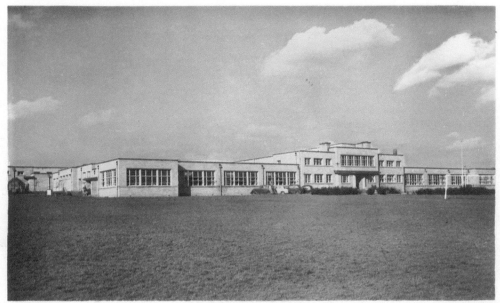

MIRFIELD MODERN SCHOOL

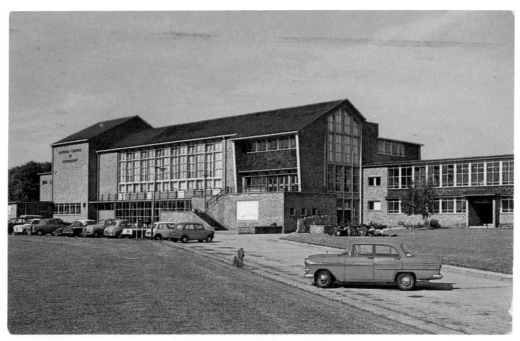

Watfield College of Technology, Hatfield

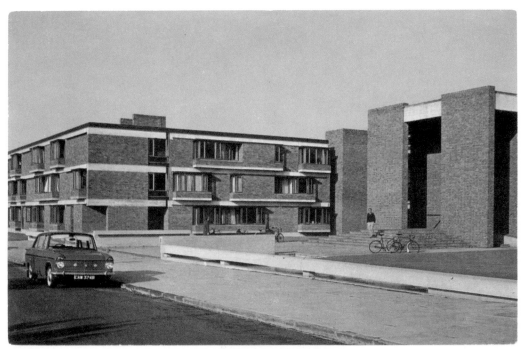

Churchill College, Cambridge

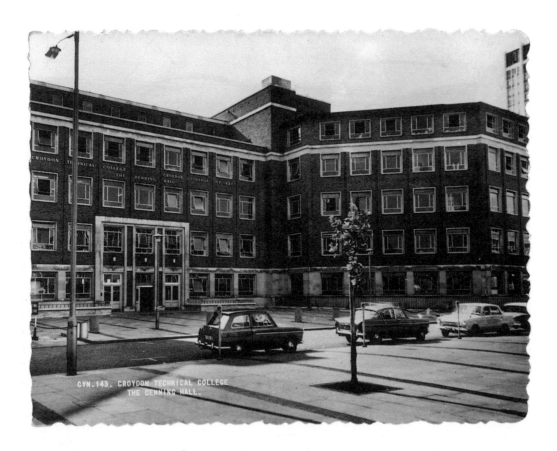

CYN. 143. CROYDON TECHNICAL COLLEGE
THE DENNING HALL.

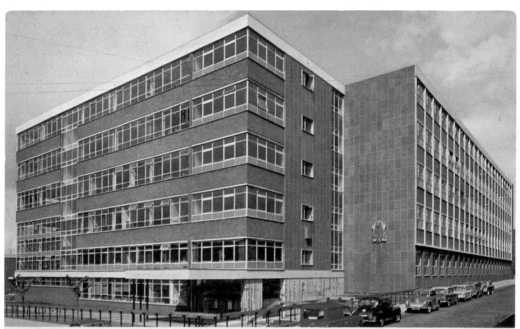

New Technical College, Blackburn

B.7216

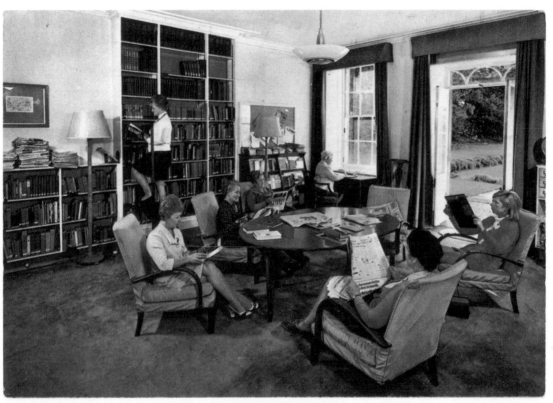

Denman College, The Library

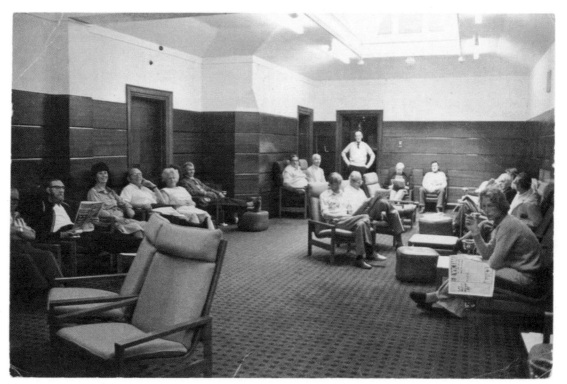

Transport & General Workers' Union Recuperation Centre, Littleport

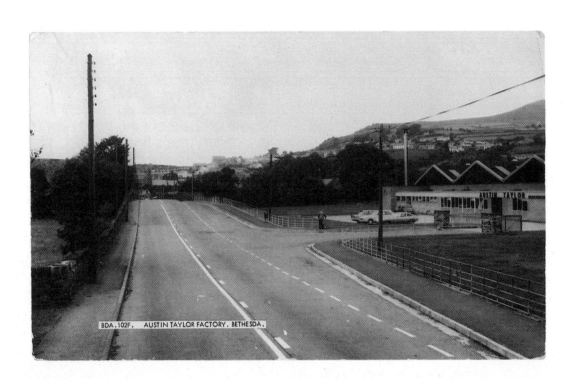

BDA.102F. AUSTIN TAYLOR FACTORY, BETHESDA.

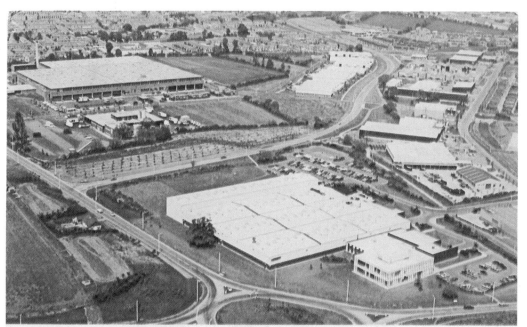

AERIAL VIEW OF REDDITCH NEW TOWN. WASHFORD INDUSTRIAL AREA

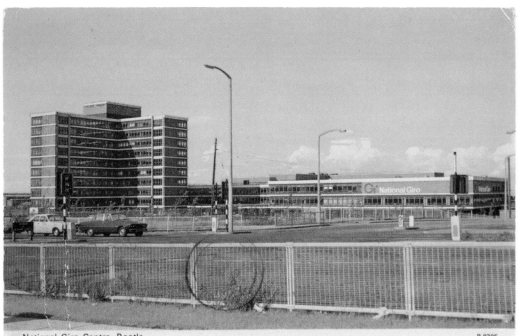

National Giro Centre, Bootle

B.9705

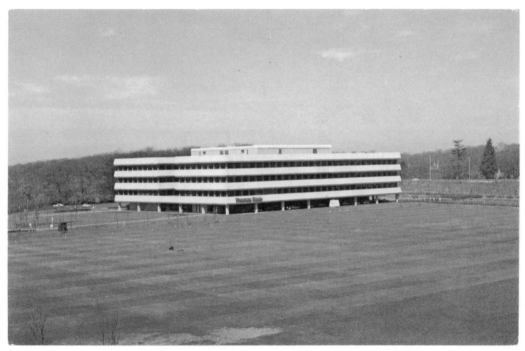

Thomas Cook International Headquarters

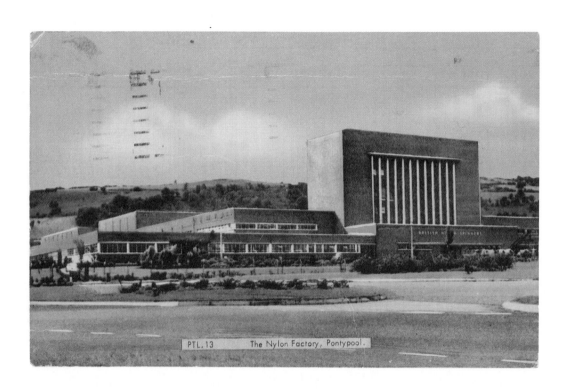

PTL.13 The Nylon Factory, Pontypool.

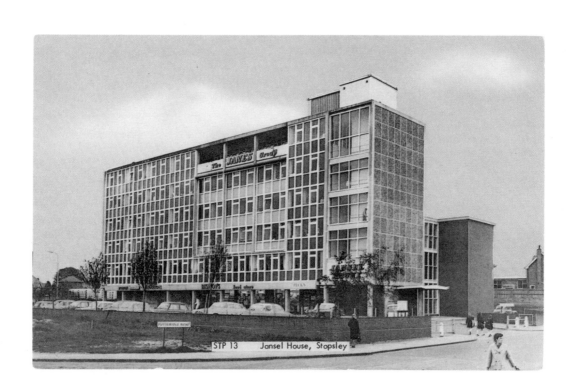

STP 13 Jansel House, Stopsley

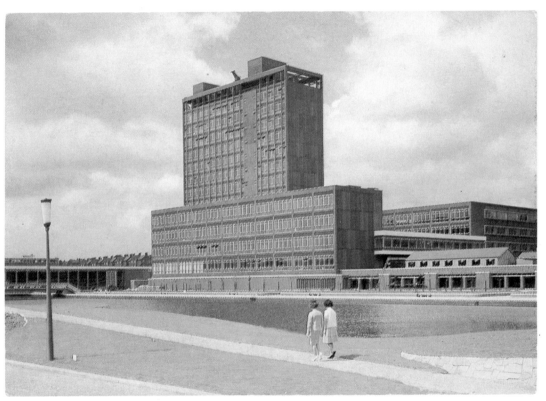

New Head Office, Pilkington Brothers Limited, St Helens

KEMNAY QUARRIES

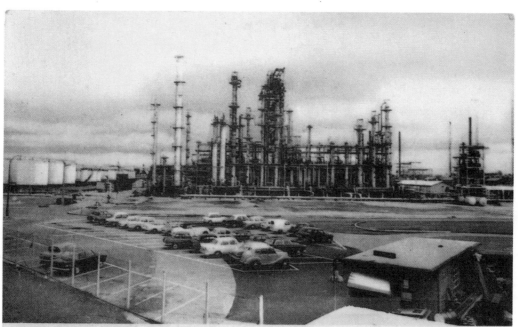

P/EP 101F THE SHELL REFINERY, ELLESMERE PORT

Promise

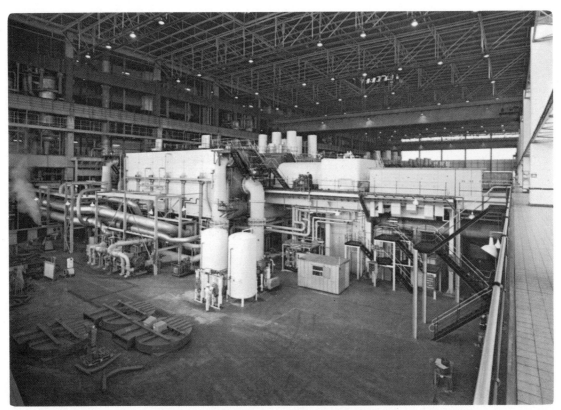

CEGB Didcot Power Station, Oxfordshire

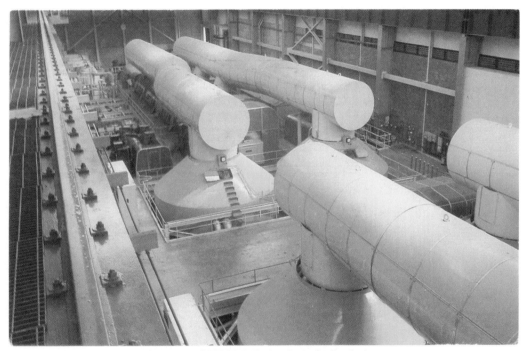

Turbine Hall, CEGB Wylfa Nuclear Power Station, Anglesey

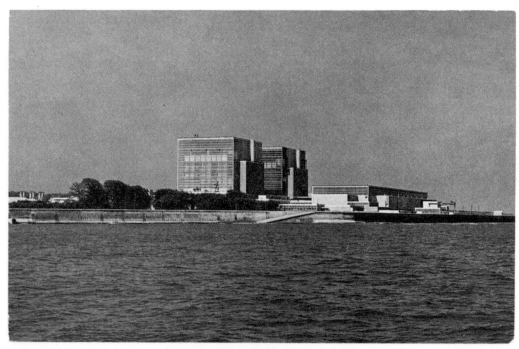

Hinkley Point Nuclear Power Station, Somerset

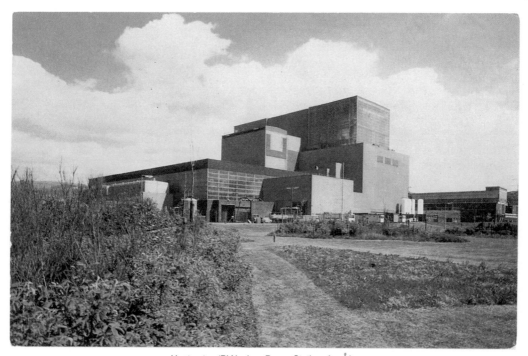

Hunterston 'B' Nuclear Power Station, Ayrshire

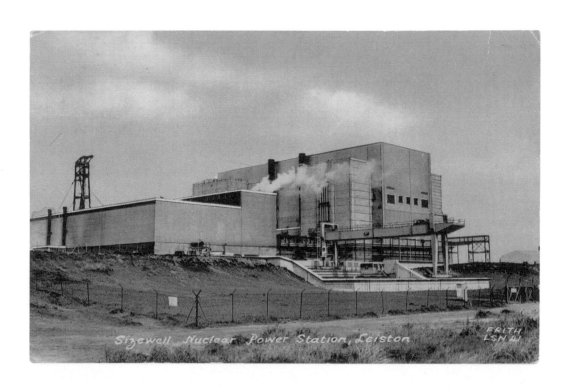

Sizewell Nuclear Power Station, Leiston

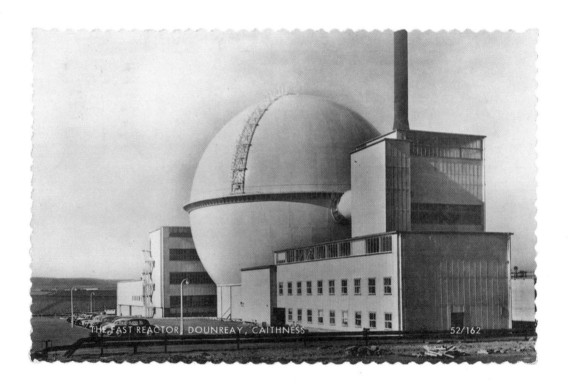

THE FAST REACTOR, DOUNREAY, CAITHNESS 52/162

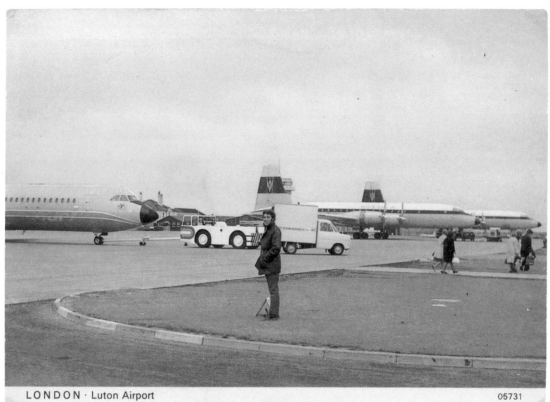

LONDON · Luton Airport

05731

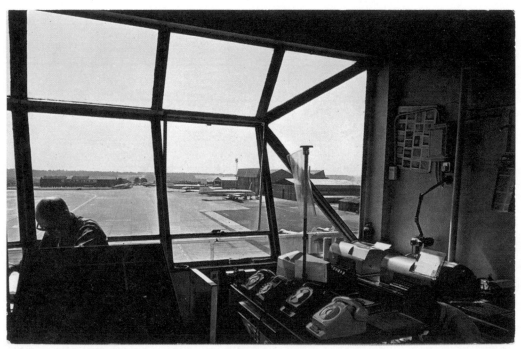

Control Tower, Luton Airport

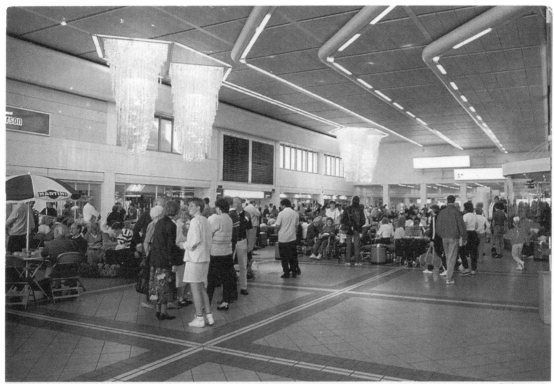

Lounge Manchester Airport

M.002109L

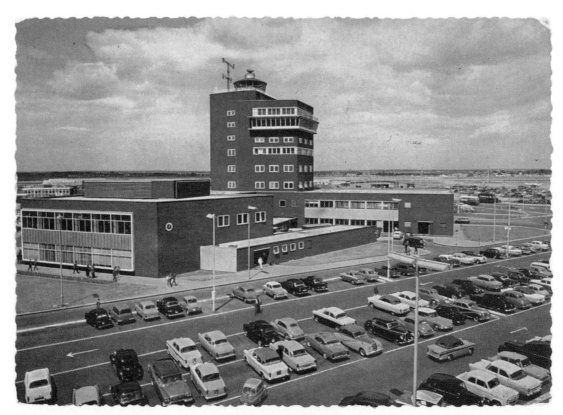

London Airport Control Tower

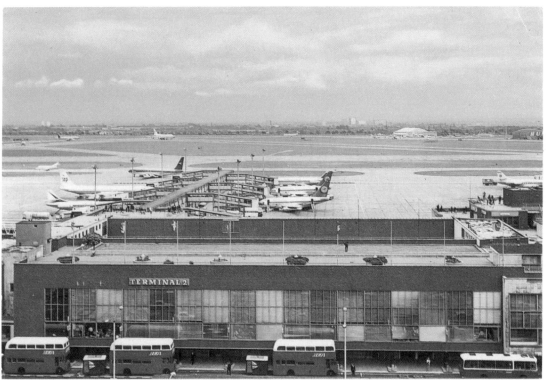

LONDON · *Terminal 2, Heathrow Airport, London.* ET5703

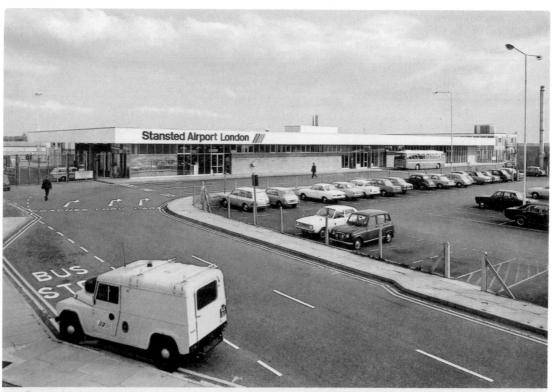

Stansted Airport · London

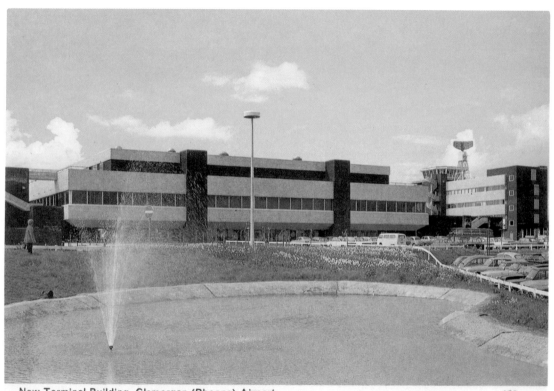

New Terminal Building, Glamorgan (Rhoose) Airport. 123

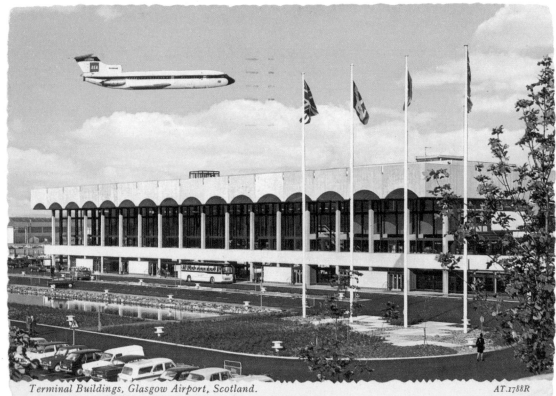

Terminal Buildings, Glasgow Airport, Scotland.

AT.1788R

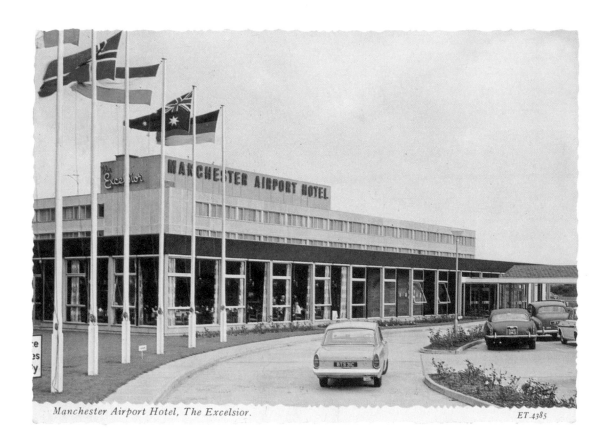

Manchester Airport Hotel, The Excelsior.

ET.4385

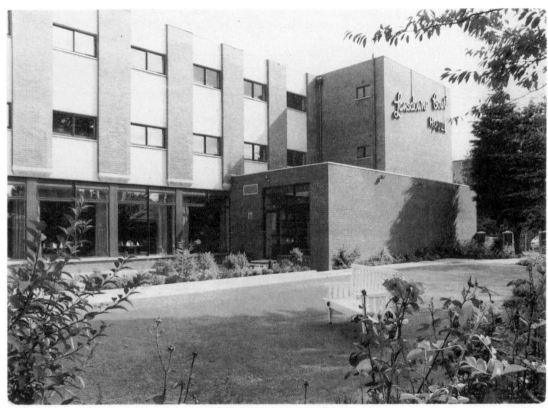

The Lansdowne Court Hotel, Belfast

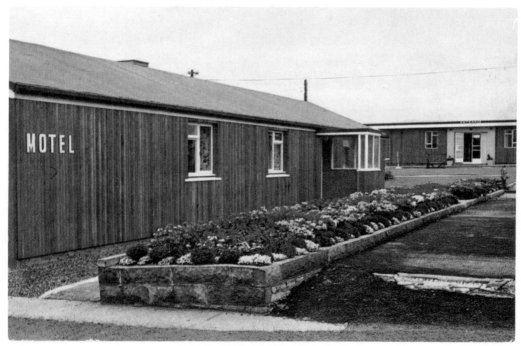

A corner of the Moota Motel, Cockermouth

The Fortes Excelsior Motor Lodge, nr. Pontefract, Yorkshire. 5672XR

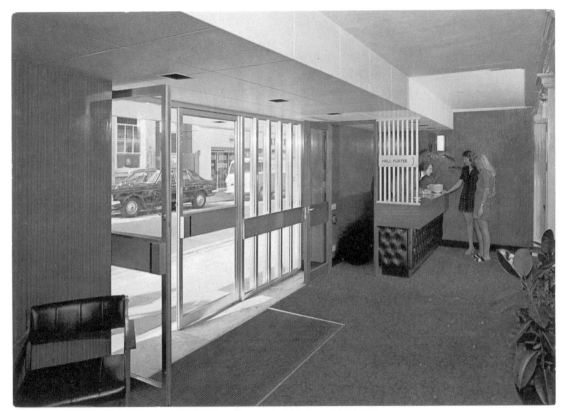

The Foyer, Ocean Hotel, Sandown, Isle of Wight

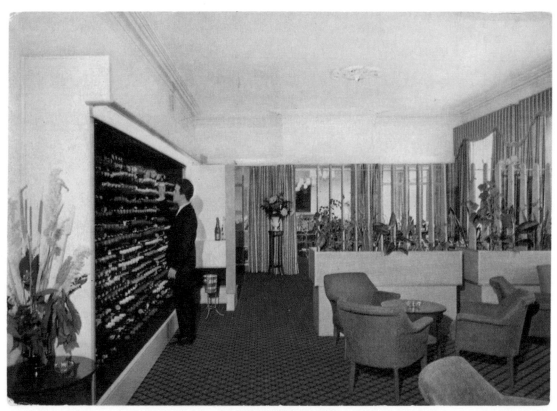

Izaak Walton Hotel, Dovedale

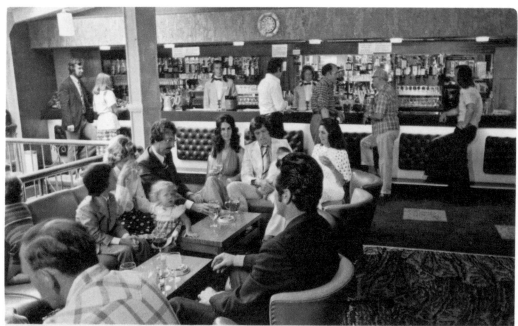

The Lounge Bar, Devon Coast Country Club, Paignton

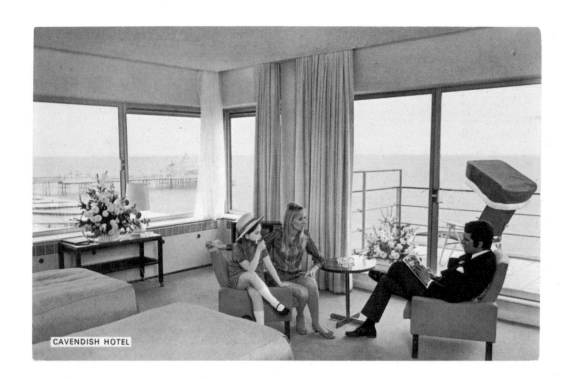

CAVENDISH HOTEL

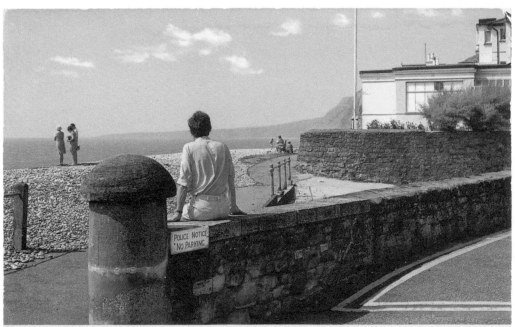

POLICE NOTICE
NO PARKING

Raleigh's Wall, Budleigh Salterton

B.2939

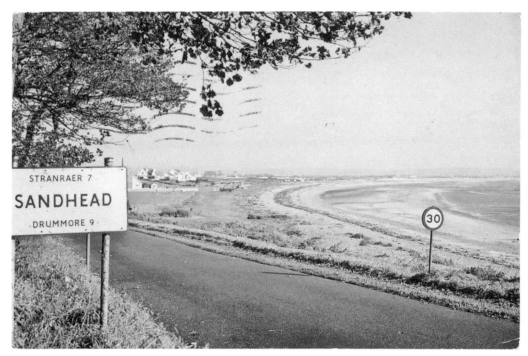

Sandhead from the South

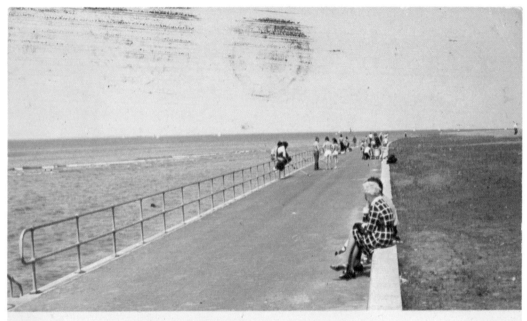

Waterloo

KN 1194

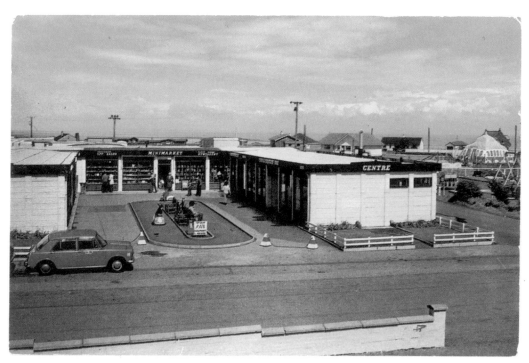

Southerness Shopping Centre

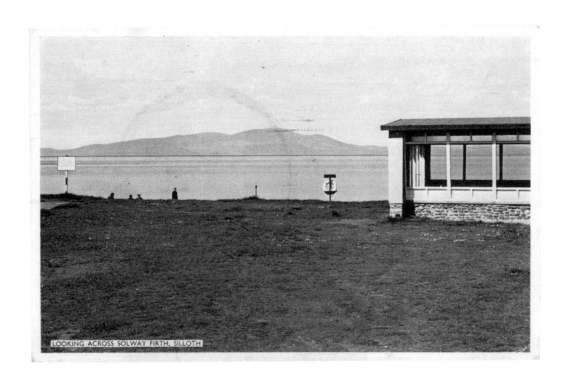

LOOKING ACROSS SOLWAY FIRTH, SILLOTH

ROSE GARDEN, SILLOTH

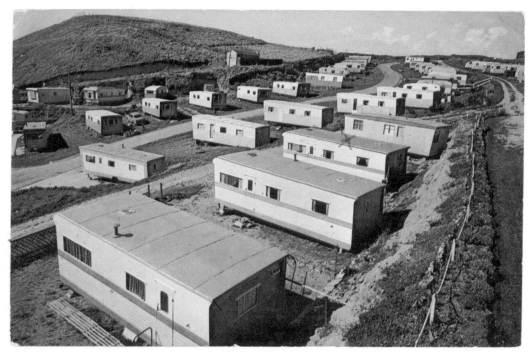

Freshwater Caravan Camp, Burton Bradstock

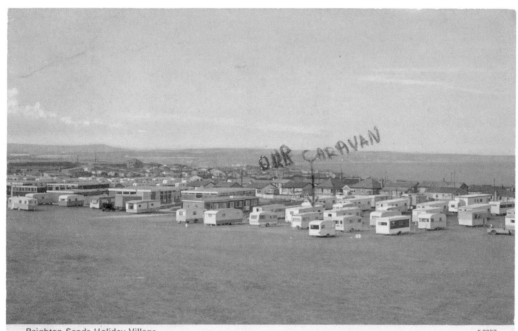

OUR CARAVAN

Reighton Sands Holiday Village F.0287

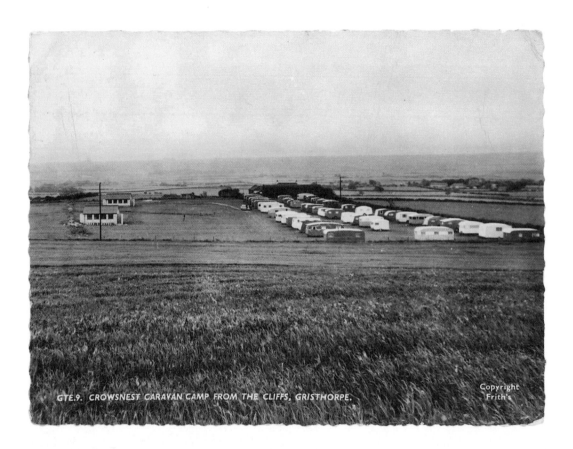

GTE.9. CROWSNEST CARAVAN CAMP FROM THE CLIFFS, GRISTHORPE.

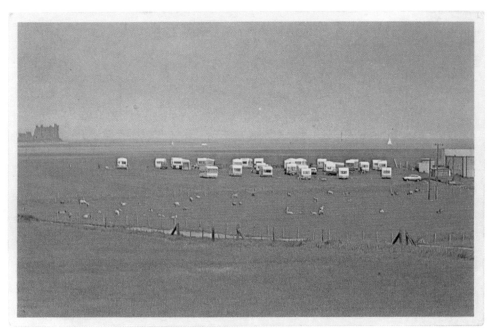

South End Caravan Park, Walney Island

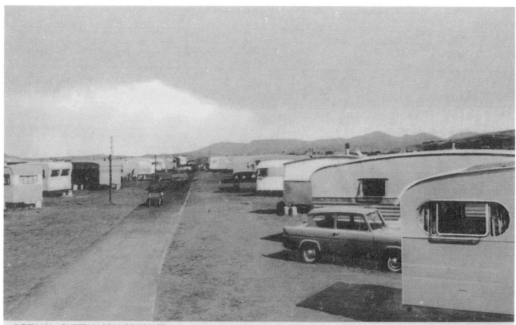

P/DFN 130 DYFFRYN SEASIDE ESTATE

Promise

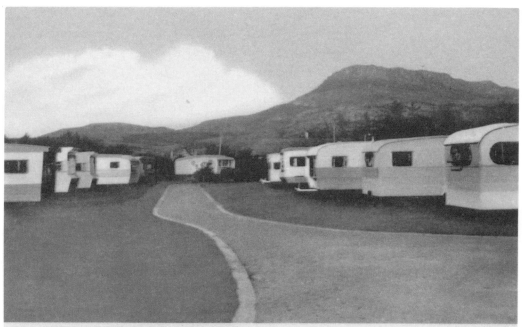

P/27 A GARREG GOCH CARAVAN PARK, MORFA BYCHAN *Promise*

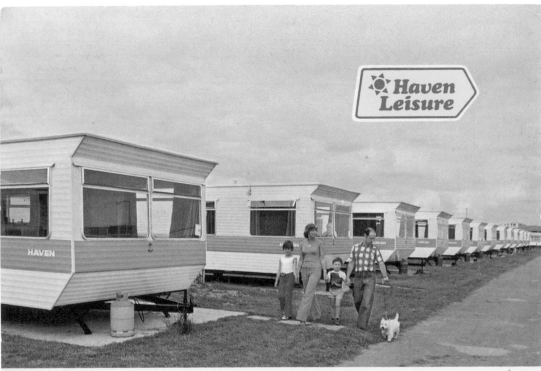

Ty Mawr Holiday Park

8028

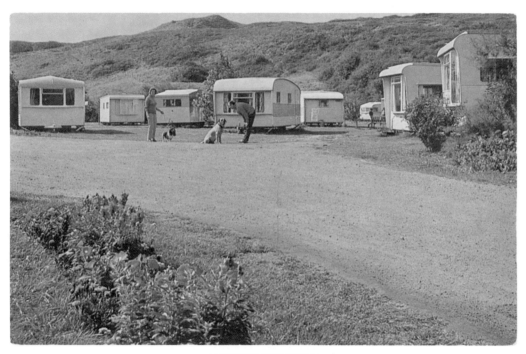

Holywell Bay Caravan Park

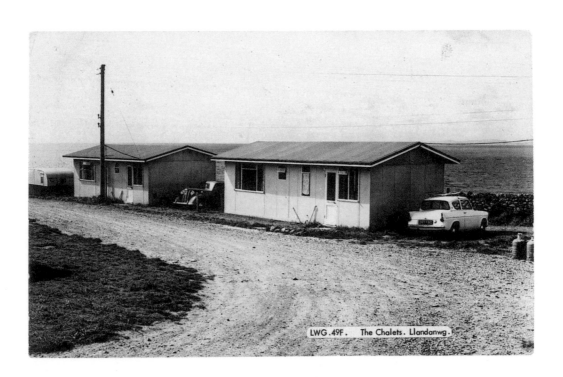

LWG.49F. The Chalets. Llandanwg.

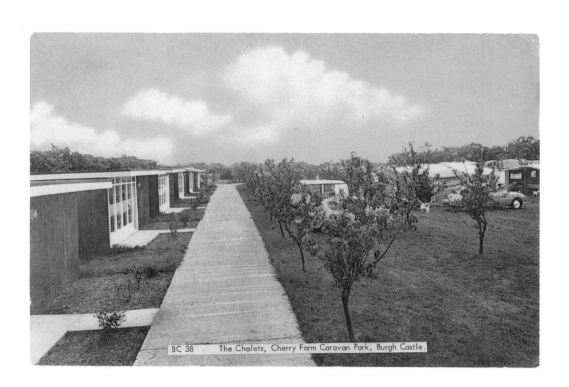

BC 38 The Chalets, Cherry Farm Caravan Park, Burgh Castle.

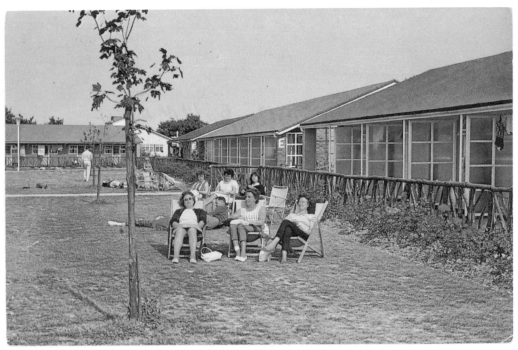

Sunshine Holiday Camp, Hayling Island, Hampshire

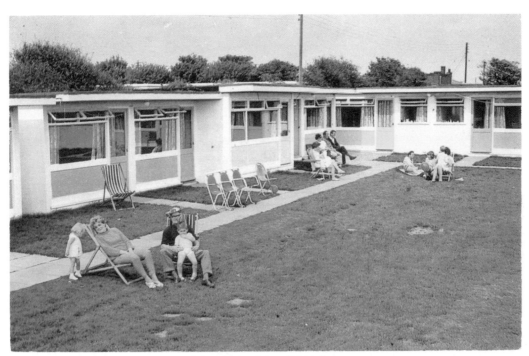

Caister Chalet, Caister Holiday Camp

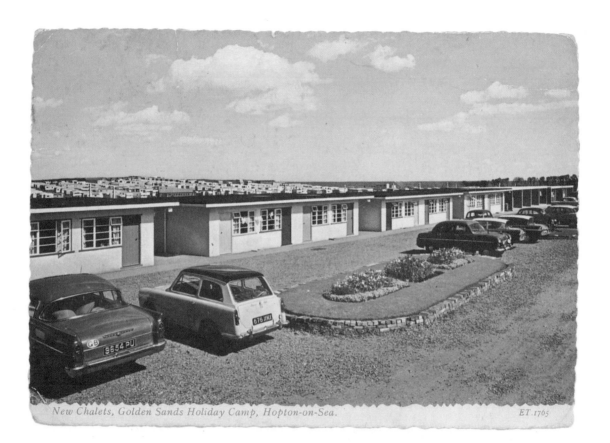

New Chalets, Golden Sands Holiday Camp, Hopton-on-Sea. ET.1765

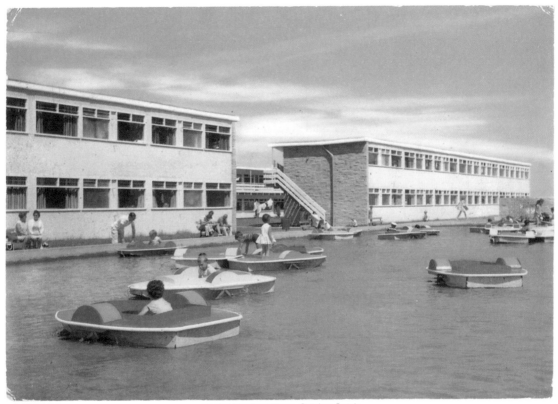

Pontins Holiday Village, Camber Sands

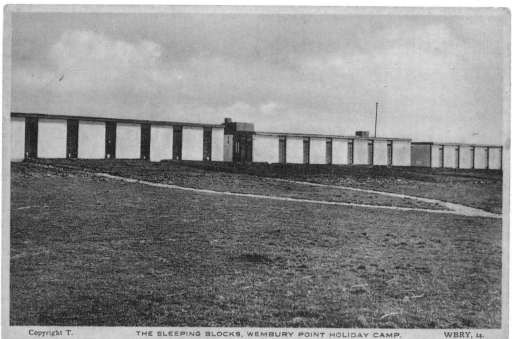

THE SLEEPING BLOCKS, WEMBURY POINT HOLIDAY CAMP.

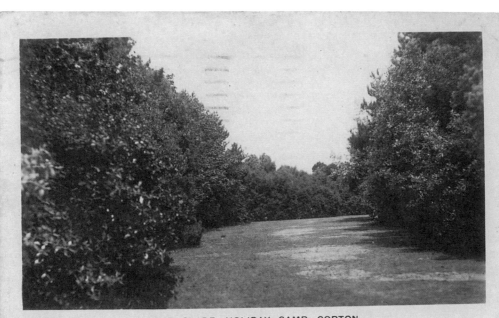

THE GLADE. HOLIDAY CAMP. CORTON.

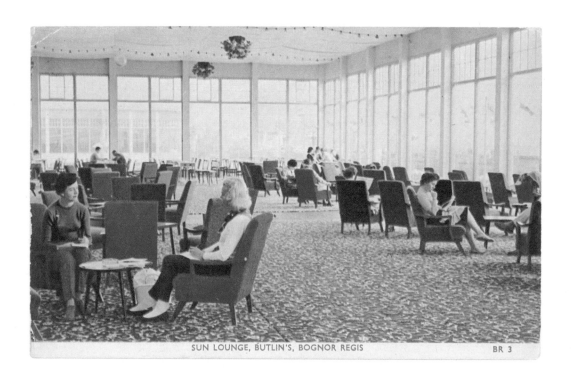

SUN LOUNGE, BUTLIN'S, BOGNOR REGIS BR 3

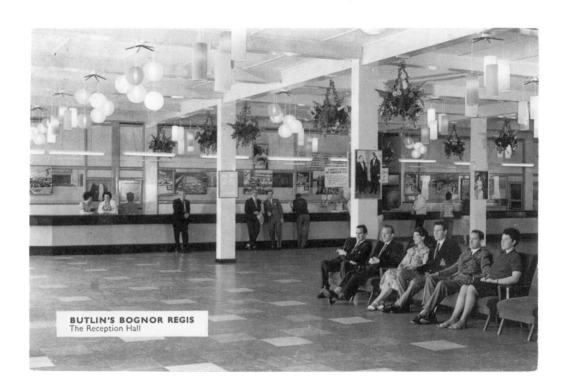

BUTLIN'S BOGNOR REGIS
The Reception Hall

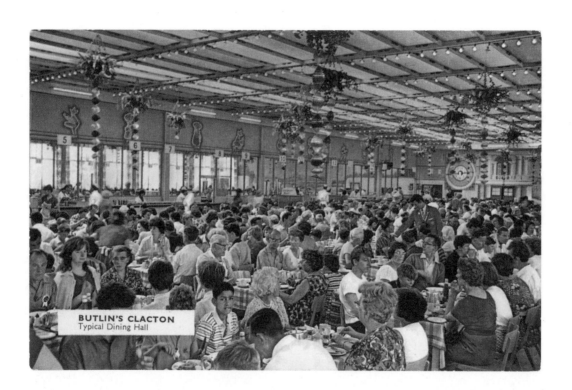

BUTLIN'S CLACTON
Typical Dining Hall

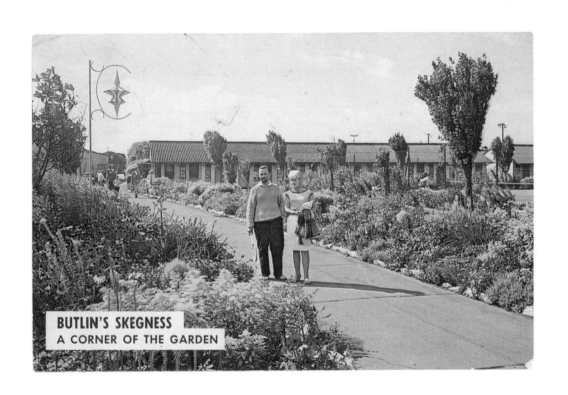

BUTLIN'S SKEGNESS
A CORNER OF THE GARDEN

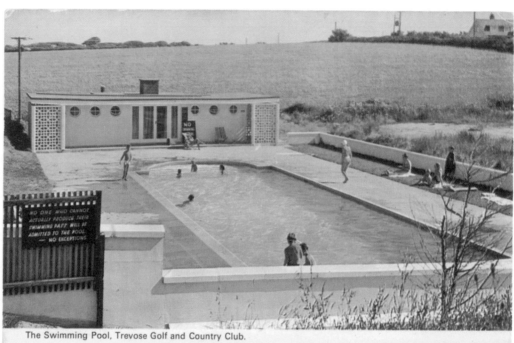

The Swimming Pool, Trevose Golf and Country Club.

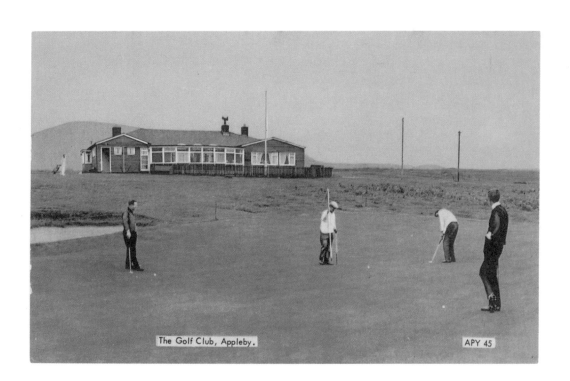

The Golf Club, Appleby.

APY 45

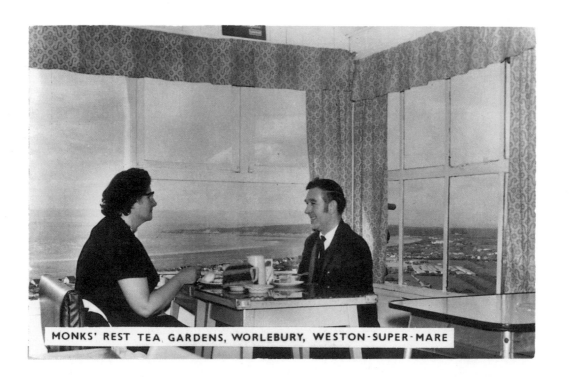

MONKS' REST TEA GARDENS, WORLEBURY, WESTON-SUPER-MARE

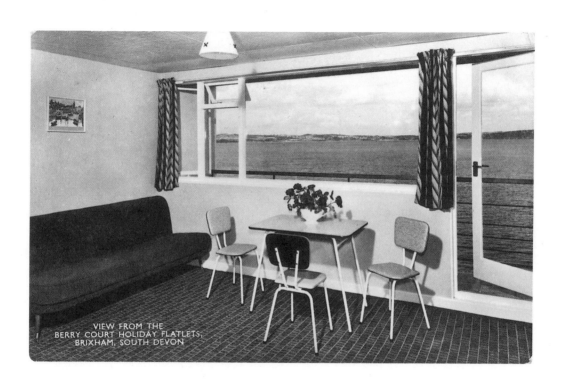

VIEW FROM THE
BERRY COURT HOLIDAY FLATLETS,
BRIXHAM, SOUTH DEVON

Tom Long's Post, Minchinhampton Common

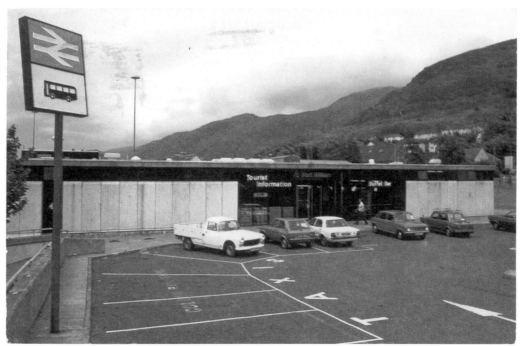

The Tourist Information Centre, Fort William

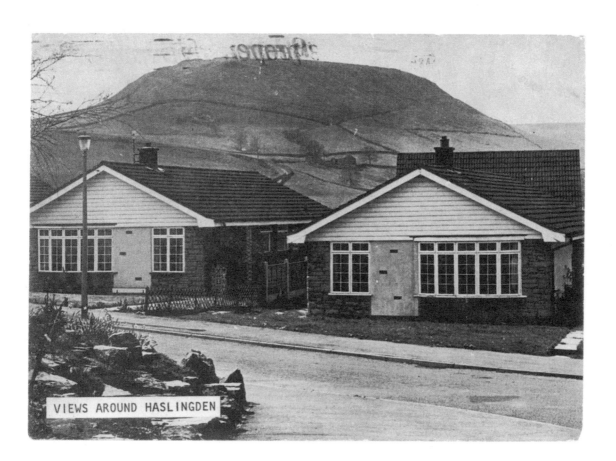

VIEWS AROUND HASLINGDEN

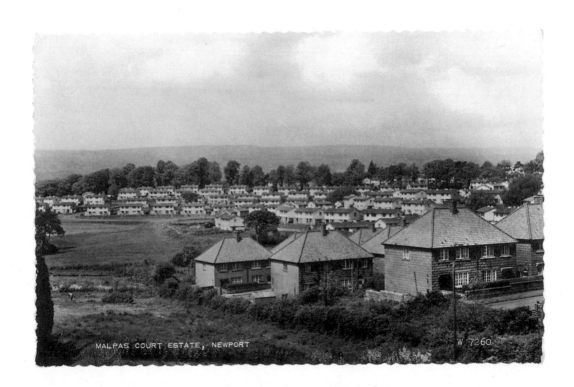

MALPAS COURT ESTATE, NEWPORT

W 7260

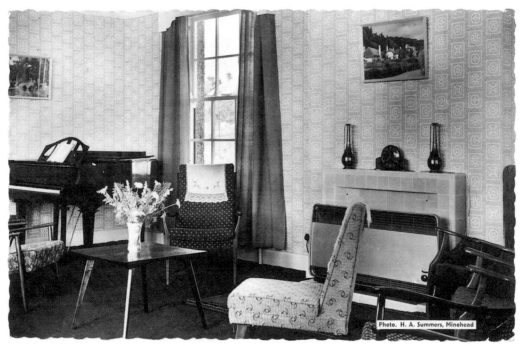

Drawing Room, "Westerley", Minehead

Photo. H. A. Summers, Minehead

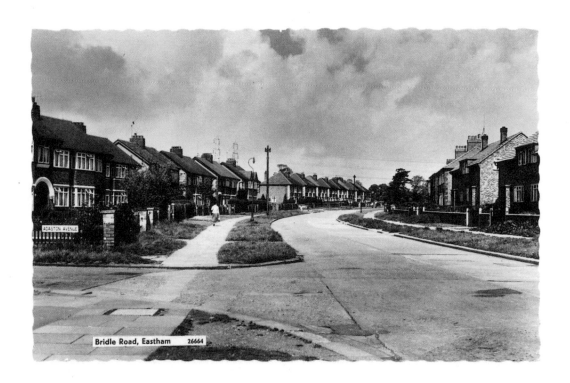

Bridle Road, Eastham 26664

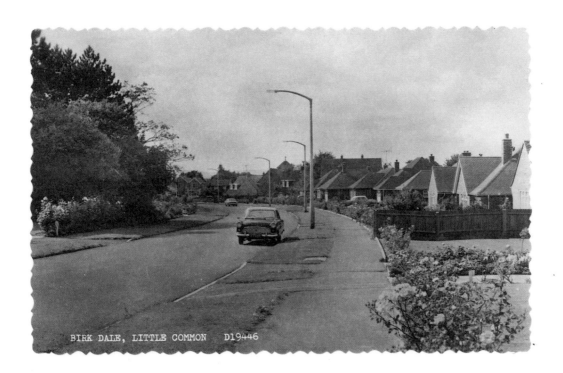

BIRK DALE, LITTLE COMMON D19446

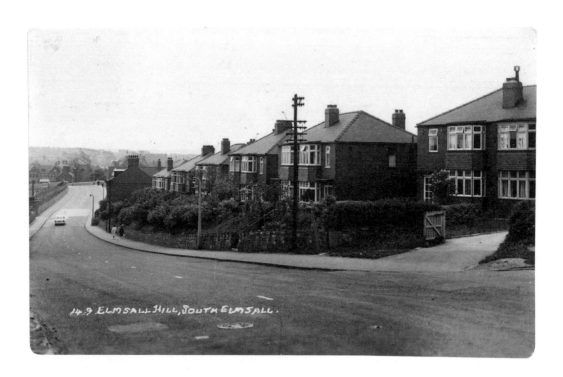

14.9 ELMSALL HILL, SOUTH ELMSALL.

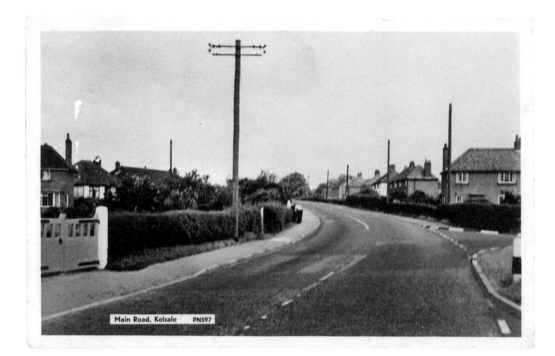

Main Road, Kelsale PN597

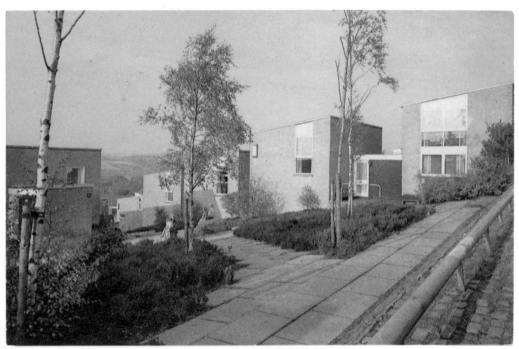
Pleasantly situated split-level houses in Cumberland

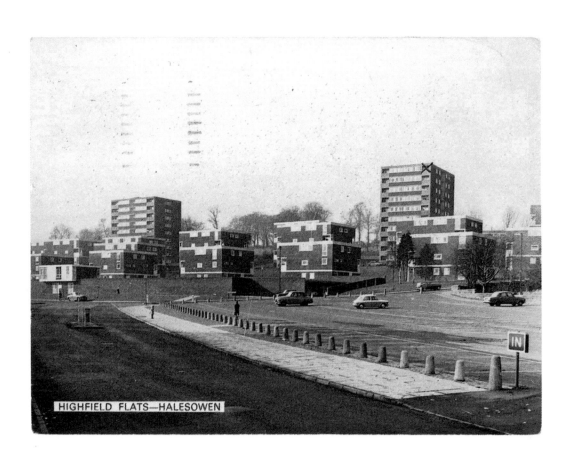

HIGHFIELD FLATS—HALESOWEN

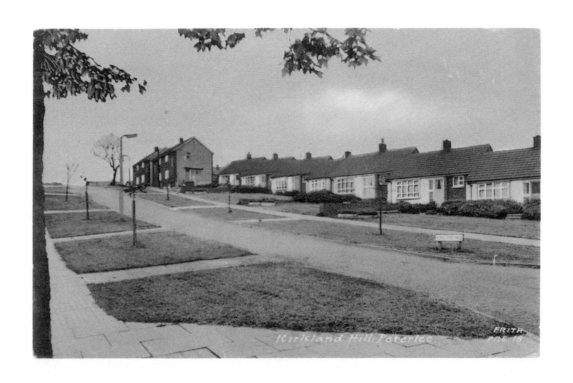

Kirkland Hill Peterlee.

ERITH
PDE 18

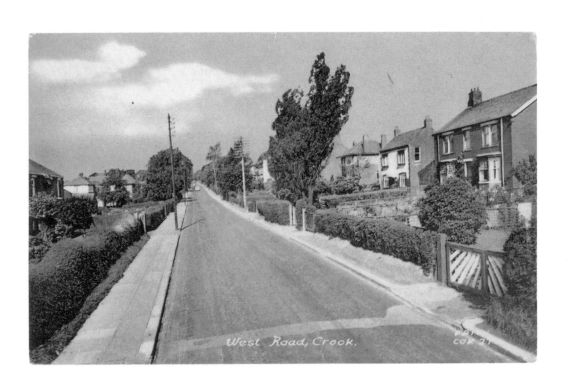

West Road, Crook.

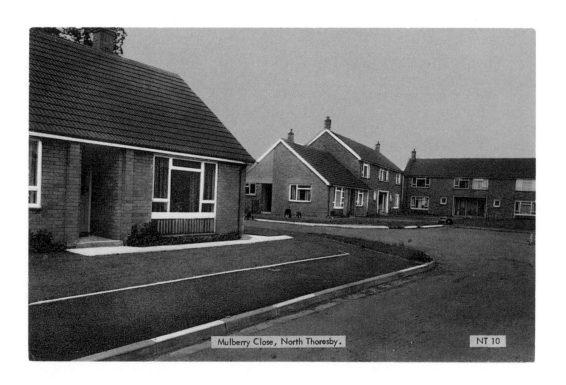

Mulberry Close, North Thoresby. NT 10

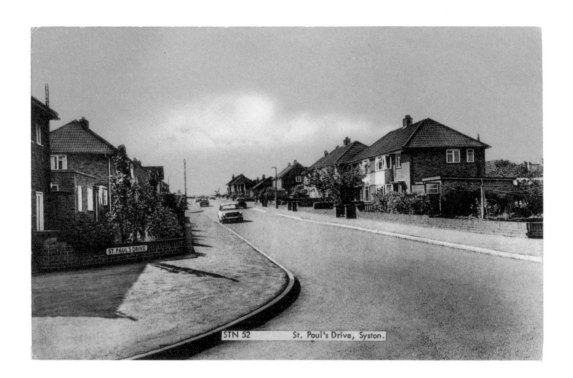

STN 52 St. Paul's Drive, Syston.

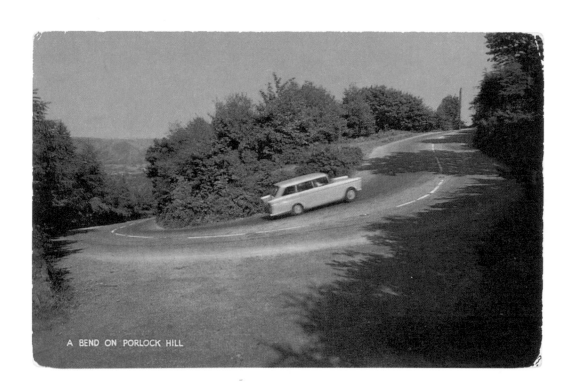

A BEND ON PORLOCK HILL

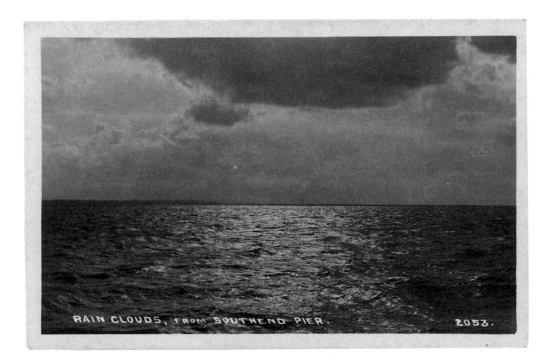

RAIN CLOUDS, FROM SOUTHEND PIER. 2053.

COLLECTION MARTIN PARR